IMAGES
of America

CHRISTMAS ON STATE STREET

1940s AND BEYOND

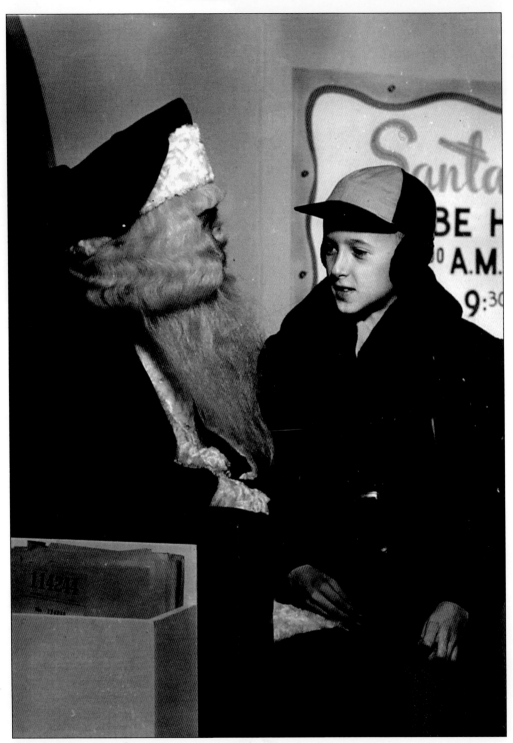

THE AUTHOR WITH SANTA.

IMAGES
of America

CHRISTMAS ON STATE STREET

1940s AND BEYOND

Robert P. Ledermann

ARCADIA
PUBLISHING

Published by Arcadia Publishing
Charleston, South Carolina

Printed in the United States of America

Library of Congress Control Number: 2002104387

For all general information, please contact Arcadia Publishing:
Telephone 843-853-2070
Fax 843-853-0044
E-mail sales@arcadiapublishing.com
For customer service and orders:
Toll-Free 1-888-313-2665

Visit us on the Internet at www.arcadiapublishing.com

*To my wonderful patient beautiful wife, Annette Marie, who fills every day of my
life with happiness, and always tries to find something good in everyone.
Without her love, guidance and encouragement this book would not have been.
Her constant determination to support one of my life's ambitions is one of a million
things I love her for....*

CONTENTS

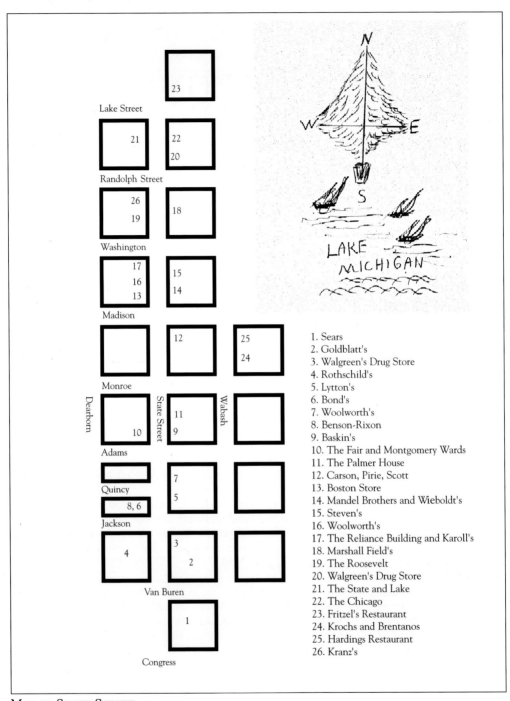

Lake Street

Randolph Street

Washington

Madison

Monroe

Adams

Quincy

Jackson

Van Buren

Congress

Dearborn

State Street

Wabash

LAKE MICHIGAN

1. Sears
2. Goldblatt's
3. Walgreen's Drug Store
4. Rothschild's
5. Lytton's
6. Bond's
7. Woolworth's
8. Benson-Rixon
9. Baskin's
10. The Fair and Montgomery Wards
11. The Palmer House
12. Carson, Pirie, Scott
13. Boston Store
14. Mandel Brothers and Wieboldt's
15. Steven's
16. Woolworth's
17. The Reliance Building and Karoll's
18. Marshall Field's
19. The Roosevelt
20. Walgreen's Drug Store
21. The State and Lake
22. The Chicago
23. Fritzel's Restaurant
24. Krochs and Brentanos
25. Hardings Restaurant
26. Kranz's

MAP OF STATE STREET.

ACKNOWLEDGMENTS

First, a sincere thank you with much appreciation to Anthony (Tony) K. Jahn, archive specialist, and Marshall Field's. Without their help this book would not have been possible. Tony is a true professional in his field.

Second, I would like to express gratitude to all the individuals involved who gave me their valuable assistance in the preparation of this book… To John Pearson, publisher, and Julia Knippen, of Arcadia Publishing. To Beverly Bricker for her patience and her computer. To Virginia Herz of the Robert L. May Company for their great photos of her family and to her sister, Barbara Lewis, for the warm memory of their Dad. To Ralph Hughes, President of The Greater State Street Council, and Veronica Bynum, administrative assistant, for their photos. To the good people at Carson, Pirie, Scott for their photos and text of Christmas Carol windows; Kathy Weber, Administrative Assistant to Chairman and Chief Executive Officer; Edward Carroll, Executive Vice President of Sales Promotion and Marketing; Julia Bentley, Senior Vice President of Investor Relations and Communications; Cindy Sanchez, Regional Director of Human Resources; and to Theodore Georgiou, Regional Merchandising Director—State Street/Visual Manager.

To Dennis Preisler and Brooke Hinricks of the Sears, Roebuck and Company Archival Department for their ad and photos. To a true gentleman, Ken Price, Director of Public Relations for The Palmer House Hilton Hotel for their information as well as photos. To Michael Polzin of the Walgreens Corporate Office Archival Department and their wonderful photos; and to Helen A. Krysa of Walgreens. To Résa A. Sanders Weir, Chuck Schaden, and Joe Angelastri for their encouragement. To Terry Texley, Department of Planning, City of Chicago, for her help; and my good friend and baseball buddy, the late Peter Nickles.

And I would be remiss if I failed to mention some of the fine people at Marshall Field's I had the pleasure to know in years past. The late Homer Sharp; the late Annette Lewin; the late Mrs. Johnny Coons; and Virginia Paxson, Pat Parks, Johanna Osborne, Addis Osborne and Sharon Roth.

And finally, I am grateful to the numerous publications as well as institutions and books that have helped me in my research to make this book a reality—The Marshall Field's archives; The Chicago Historical Society; The Special Collections Department of the Harold Washington Library; Dartmouth College Library, Hanover, New Hampshire; *The Chicago Sun-Times*, The *Esquire Magazine* November 1965 issue; *The Daily News*; *The Chicago Tribune*; The Palmer House Hilton 'News' releases; the booklet, *Unlock the Treasures of the Palmer House Hilton*, printed by Print King, Inc.; The Maurice L. Rothschild's employee manual of 1964; the Third Edition of *Walking Tours of Chicago Architecture*, by Ira Bach, published by Rand McNally & Co. 1973/1977; *Chicago City of Neighborhoods 1986*, by Dominic A. Pacyga and Ellen Skerrett, published by Loyola University Press; *See Chicago On Your Own*, by Marie Bergren, 1951/1955 published by Ziff-Davis; *The Great American Christmas Almanac*, by Irena Chalmers, published by Viking Studio Books/Penguin Group, NY, NY; *Chicago Portraits*, by June Skinner Sawyers, published by Loyola Press 1981; *Carson, Pirie, Scott/Louis Sullivan & The Chicago Department*

Store, by Joseph Siry, published by University of Chicago Press 1988; *The Best Christmas Decorations in Chicagoland*, by Mary Edsey, published by Tabagio Press Chicago 1995; *Rudolph the Red Nosed Reindeer*, by Robert L. May, published by Applewood Books, facsimile 1967 edition; *Chicago on Foot*, by Ira J. Bock and Susan Wolfson, revised by Jane Cornelius, published by Chicago Review Press 1954; *Chicago Interiors/Views of a Splendid World*, by David Lowe, published by Contemporary Books Chicago 1979; *Chicago In and Around the Loop*, by Gerald R. Wolfe, 1996; *Lost Chicago*, by David Lowe, published by Houghton Mifflin Co., Boston; *Chicago Walking, Bicycling and Driving Tours of the City*, by Norman Marks, published by Chicago Review Press 1987. Thanks also to Pat Bakunas of the University of Illinois at Chicago for permission to reproduce several photos from the Chicago Photographic Collection (C-7441, A-6386, 4-1144, 57-S-24, D-5746, D8428, 61-S-6, D3213, W-5763A) Department of Special Collections—The University Library—University of Illinois at Chicago.

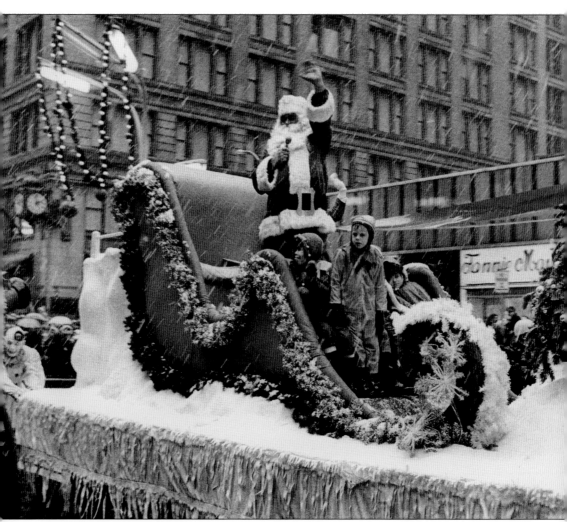

1968 STATE STREET PARADE. Pictured is Santa and unidentified children on State Street just passing Washington Street heading south. (Photo courtesy The Greater State Street Council.)

8

INTRODUCTION

Most Americans, no matter what their ethnic background or heritage may be, celebrate the holidays, and still in our ever changing world, throngs of nostalgic-minded people young and old alike come back to Chicago's State Street at Christmas time. These traditions are kept in a small corner of our hearts, in a place that is filled with warm, sweet memories. State Street's appeal keeps people coming back year after year to honor a holiday tradition unique to Chicago's long and proud history.

Let us go back to Christmas 1946—the days are filled with news. In Washington, DC, President Harry Truman delivers his Christmas message to the nation from the south lawn of the White House. Locally, Edward J. Kelly, mayor of Chicago since 1933, decides not to seek another term in office. The air outside is cold and crisp and creates a feeling of Christmas excitement. Each building has its own architectural details, but all individually contribute to the charm that is Chicago's State Street.

As we journey back to visit some of the great stores that were, and in some cases remain, located on State Street, I hope I will mention a favorite of yours. Christmas was a magical time of year, and in the days surrounding the holidays State Street came to life. Those days were wonderful.

Starting at the south end of the Loop and heading north on State Street, every store window was alive with THE HOLIDAY SEASON….

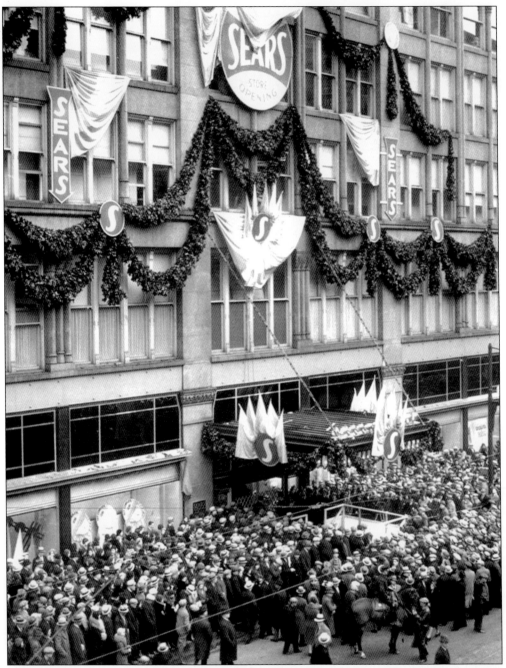

SEARS, ROEBUCK & CO. GRAND OPENING OF 1932 WITH CROWDS. (Photo courtesy of and reprinted by arrangement with Sears, Roebuck and Co.)

One

SEARS AND GOLDBLATT'S

Sears, located at the southeast corner of State and Van Buren, was designed by William Le Baron Jenney in 1891. Levi Z. Leiter, and former partner of Marshall Field, built the structure as an income property. After completion, Siegel, Cooper and Co. occupied the department store, which was known as the second Leiter's building in the Loop. Sears, Roebuck and Company purchased the building in 1932 and called it "The World's Largest Store." It is interesting to note that at that time Sears owned a radio station with the call letters WLS, or "World's Largest Store." Before coming to Chicago to start his catalog and mail order business, Sears as a young man started selling pocket watches while working on the Minnesota railroads.

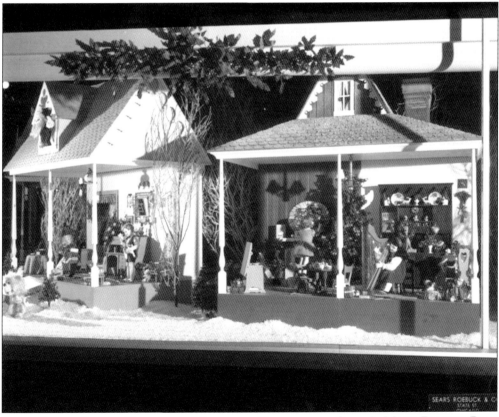

SEARS STATE STREET CHRISTMAS WINDOWS, DEPICTING A CHILD'S MAKE BELIEVE PLAY HOUSE. (Photo courtesy of and reprinted by arrangement with Sears, Roebuck and Co.)

SEARS STATE STREET STORE—CHRISTMAS 1950S. Note the three store managers (unidentified) at right wearing their carnations. (Photo courtesy of and reprinted by arrangement with Sears, Roebuck and Co.)

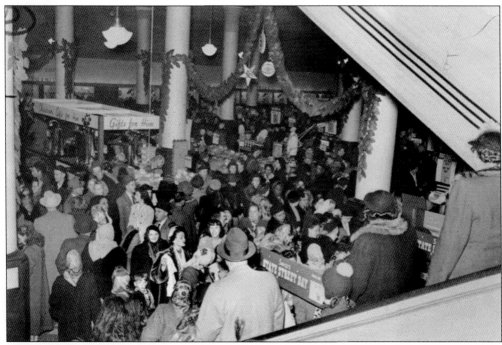

SEARS STATE STREET STORE ADVERTISING "SEARS STATE STREET DAY"—CHRISTMAS 1950S. (Photo courtesy of and reprinted by arrangement with Sears, Roebuck and Co.)

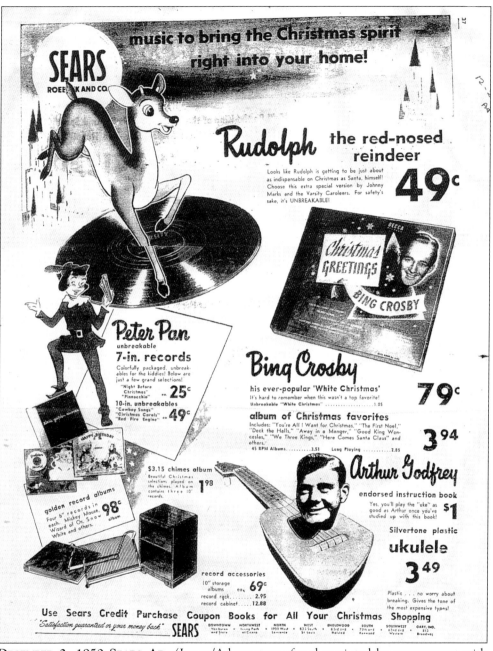

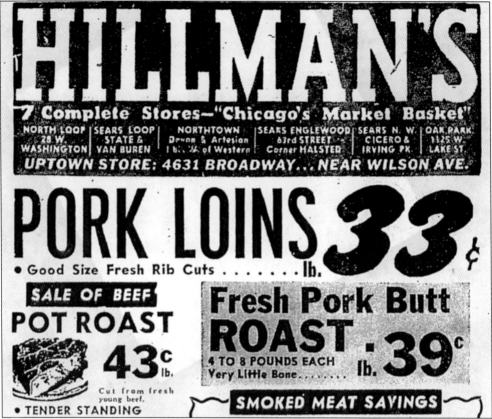

PORTION OF DECEMBER 1, 1950 HILLMAN'S AD. When Sears was on State Street, in the early days, the basement of the building had a "Hillman's" food store, with selections of delectable foods, meats, and more. As you entered the store the aroma of all the fine delicious tidbits filled the air. A shopper could buy fresh hams, turkeys, and imported cheeses, as well as candies, marzipan, fresh citrus, figs, dates, chestnuts, and other fine delicacies, surrounded by walls of gleaming white tiles. You could almost imagine Bob Cratchit running about the store, picking up all the little confections and goodies for his family's great Christmas feast.

The outside window displays at Sears focused mainly on winter clothing and household furniture. Hillman's had one window to display some of their holiday food specialities. The large main window at State and Van Buren was filled with toys. Everything a child could wish for, and more, was in that window. There were bicycles, electric trains, wagons, scooters, games, puzzles, dolls and doll houses, and painting sets. You could see the twinkle in children's eyes when they saw that window.

Sears remained at that location until late 1983, when the Anvan Realty and Management Company, at an undisclosed price, renovated and reopened the building as an office complex that included an educational facility and retail space on the ground floor. Sears returned to State Street in 2001, at State and Madison Street in the old Boston Store location.

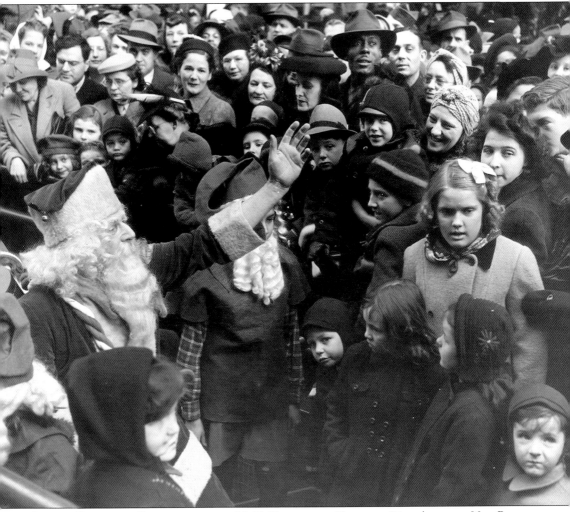

SANTA GREETING CROWDS AT THE 1943 CHRISTMAS PARADE. Directly across Van Buren Street at 333 S. State Street was Goldblatt's Department Store. It was built by architects Holabird and Roche in 1912 for the A.M. Rothschild and Company Store, which in 1923 was replaced by the Davis Store. In 1936 the Goldblatt Brothers moved into the location.

The Goldblatt brothers made their beginnings in 1914 in a small store front at 1617 W. Chicago Ave. They participated in the workings of the store. The two older brothers, Maurice and Nathan, took care of most of the buying and business details, while the two younger brothers, Louis and Joel, handled various other tasks. These Polish immigrant brothers had made a bond to come to America and make something of themselves. This small beginning was a far cry from the ten story, three basement building they would occupy on State Street until 1981, when their downtown store finally closed.

Animation was used for the windows, which would tell a story such as the "Adventures of the Gingerbread People in Gingerbread Land."

The bargain basement was known for good merchandise at lower prices. The basement consisted of a household department, a fabric department, a notions department, and much more.

Up on the 8th floor, Goldblatt's toy department took up the entire floor. When a child left the store his or her heart would be filled with the excitement of what was still to come. (Photo courtesy The Greater State Street Council.)

15

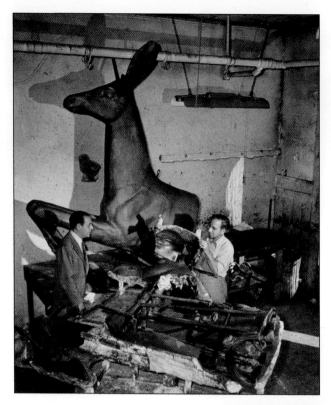

PAPIÉR MACHE REINDEER. Joel Goldblatt, former President of The State Street Council, inspects the papiér mache covering fitted over plaster forms in this 1948 photo. Forms for the reindeer were braced with steel tubes, built in two sections, and then fitted together. (Acme Photo Service. Photo courtesy of The Greater State Street Council.)

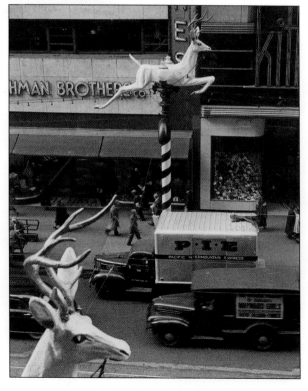

REINDEER FROM ABOVE. Shoppers see the completed reindeer on top of the State Street lights from one end of State Street to the other. At Christmas time, Goldblatt's had their windows decorated similarly to Sears with merchandise for the home and family. The Richmond Brothers Clothing Store is in the background. (Photo courtesy of The Greater State Street Council.)

Two

WALGREENS DRUG STORE, LYTTON'S, AND ROTHSCHILD'S

Walking further up the street you can see and hear the sights and sounds of Christmas everywhere, from the lamp posts with their giant Christmas wreaths and reindeer to the corner Santas ringing their brass bells collecting donations for the Salvation Army. Amid the hustle and bustle of all the shoppers, we head north on State Street.

At the southeast corner of State and Jackson was Walgreens Drug Store. Charles R. Walgreen Sr. had energy and enthusiasm that soon led to new ideas and an ambitious expansion. He began manufacturing his own line of drug products to ensure high quality and low prices. In the 1950s customers saw a transition from full-service to self-service.

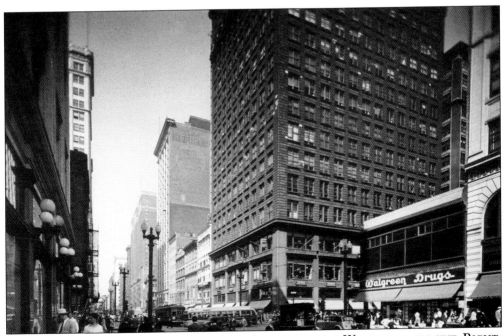

STATE STREET LOOKING NORTH TOWARD JACKSON, WITH WALGREENS ON THE RIGHT. (Photo courtesy of The University of Illinois at Chicago—The Univ. Library Department of Special Collections—Chicago Photograph Collection.)

17

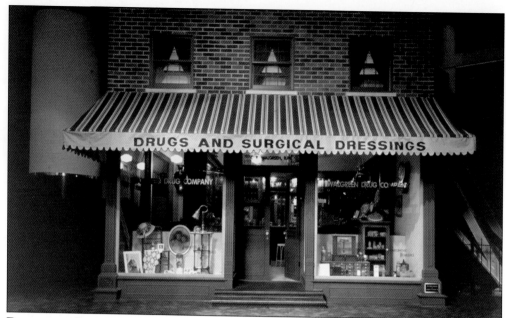

DRUGS AND SURGICAL DRESSINGS. Back in 1901 Charles R. Walgreen Sr. purchased the south side drugstore where he had been working as a pharmacist. Today a replica of this original store in Chicago can be seen in the Museum of Science and Industry. (Photo courtesy of Walgreens.)

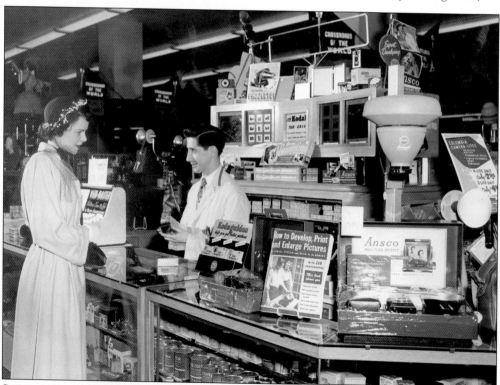

SERVICE CLERK FRANK HAINES, SEEN IN 1951 WITH UNIDENTIFIED CUSTOMER AT PHOTO COUNTER. (Photo courtesy of Walgreens.)

**UNIDENTIFIED LADIES AT
WALGREENS PERFUME BAR 1940S.**
(Photo courtesy of Walgreens.)

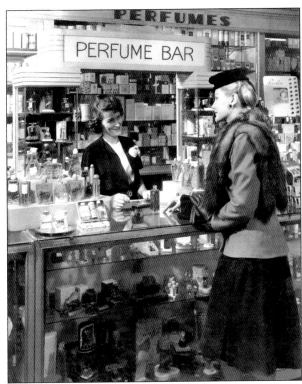

**A TYPICAL LUNCH COUNTER
IN THE 1940S.** (Photo courtesy
of Walgreens.)

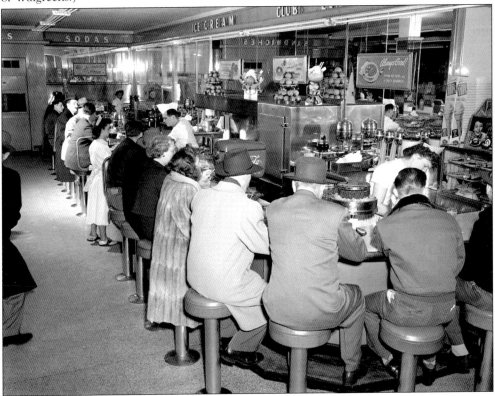

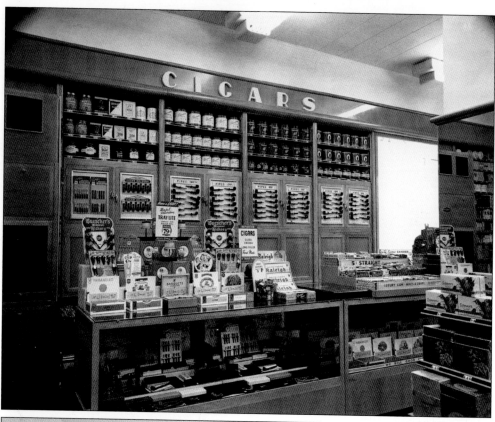

© R.P. Ledermann

CIGARS. In years past a gift of tobacco would have been purchased from a Cigar Counter. (Photo courtesy of Walgreens.)

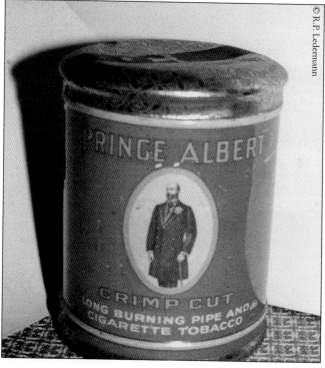

A PRINCE ALBERT TOBACCO TIN.

WALGREENS IN THE OLD BOSTON STORE BUILDING AT STATE AND MADISON STREET. As of 2001 the new Sears is in this location. (Photo courtesy of Walgreens.)

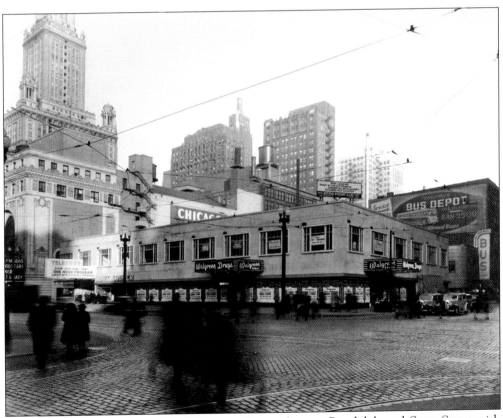

RANDOLPH AND STATE, 1940s. Walgreens is seen here at Randolph and State Street with the Chicago Theatre up the street and the Trailways bus depot to the right. (Photo courtesy of Walgreens.)

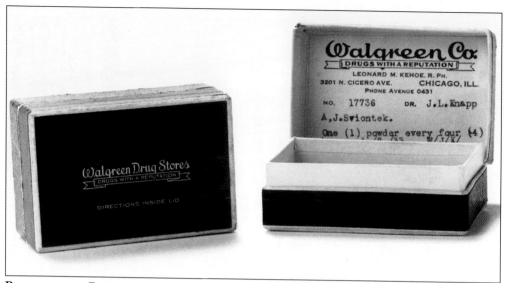

PRESCRIPTION BOX WITH PATIENT INFORMATION LABEL FROM 1933. During the 60s Walgreens filled its 100 millionth prescription, far more than any drug chain at that time. In 1968, Walgreens became the first major drug chain to put its prescriptions into child-resistant containers, long before it was required by law. (Photo courtesy of Walgreens.)

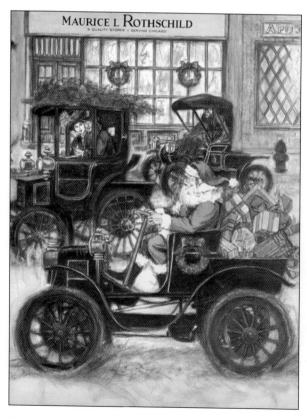

COVER OF A CHRISTMAS CATALOG FROM THE 1960s. (R.P. Ledermann Collection.)

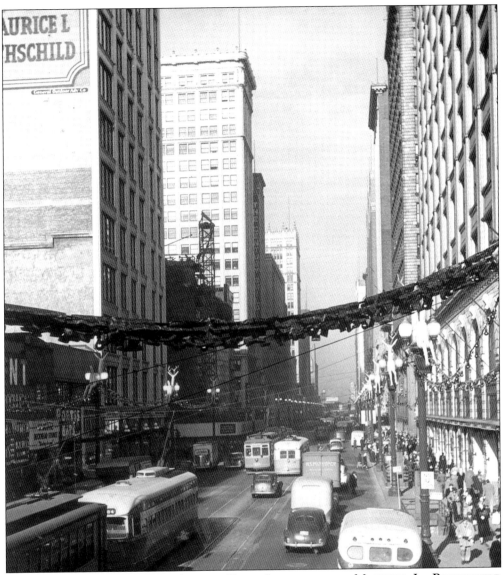

LOOKING NORTH ON STATE STREET NEAR JACKSON, THE MAURICE L. ROTHSCHILD CLOTHING STORE IS SEEN ON THE LEFT WITH GOLDBLATT'S ON THE RIGHT. On the southwest corner of State and Jackson was Maurice L. Rothschild's, a clothing store for the entire family. The store was built with a reputation for handling top quality merchandise, with world famous fashions and brand labels of the day like Botany 500, Hickey Freeman, Kupperhimer, Eagle Suits, Johnson and Murphy, Allen Edmonds, Freeman Shoes, Van Huesen and Hathaway Shirts, and Stetson Hats. One complete floor was devoted to women's shoes. Rothschild's also had its own tailor shop and fur storage.

Each Rothschild's window at Christmas time would be filled with clothing from these fine manufacturers, showcasing everything from smoking jackets and silk robes to fine suits.

Entering Rothschild's at the south wall of the ground floor you encountered an impressive bank of elevators with elegant wrought iron gates and uniformed operators at the ready. Rothchild's closed its State Street store in the early 1970s. (Photo courtesy The Chicago Historical Society ICHI-34903/Photographer Otto B. Turbyfill—12-22-48.)

THE HENRY C. LYTTON BUILDING. (Photo courtesy of The University of Illinois at Chicago—The Univ. Library Department of Special Collections—Chicago Photograph Collection.)

LYTTON'S CHRISTMAS GIFT BOX.

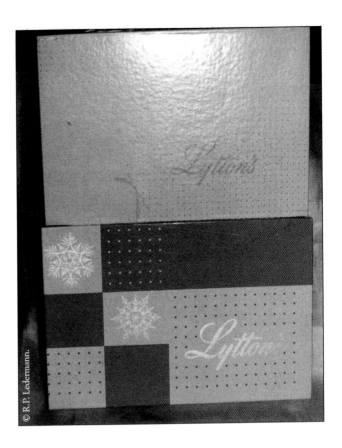

© R.P. Ledermann.

On the northeast side of State and Jackson was Henry C. Lytton's Clothier. Known in the early days in Chicago as "The Hub," its name was changed to celebrate the 100th birthday of its founder, Henry C. Lytton, in July 1946. Mr. Lytton was a pioneer, whose insight made it possible for the rebuilding of this section of south State Street that had been destroyed by the Great Chicago Fire. It is interesting to note that back in 1888 State Street shoppers stared at the display window and couldn't believe what they saw: Henry C. Lytton in a tuxedo sawing wood! As the *Sun-Times* article from October 28, 1979, indicates, he was paying off on an election bet on Grover Cleveland, but what it did was attract customers into the store.

"It was a wonderful stunt," he later said. "Thousands of people came and extra police were called to clear State Street." The *Sun-Times* article continues, "That's what really mattered in 1888 and that's what matters today, getting people to come to State Street to spend their money on merchandise. . ."

Not all the department stores, or dry goods emporiums, as they were called then, were as flamboyant as Lytton's. Before he died in 1949 at age 102, Lytton staged the first 'wedding' in a window, set off 100 balloons filled with gift certificates, and threw 100 overcoats from the store roof.

At Christmas time in the 1950s and 1960s, a bright red wool vest with brass buttons was worn with pride by all the salesmen. In the 1960s as a young man, I was one of them.

The motto of the store was the 'The Lytton Look.' All of us were advised to keep and maintain that look when we greeted our customers.

The Lytton windows would be filled with the equivalent of name brand clothing, just as the windows of their competitor, Rothschild, across the street. In each window, strategically displayed, were the famous red and white Christmas gift boxes with gold Lytton lettering.

This poem was passed to all salespersons by our floor walker. He indicated that it was found posted in a wine cellar in the city of Paris. The author is unknown. . .

GOOD BUSINESS

If I possessed a shop or store,
I'd drive the grouches off my floor.
I'd never let some gloomy guy
Offend the folks who come to buy.
I'd never keep a boy or clerk
With mental toothache at his work;
Nor let a man who draws my pay
Drive customers of mine away.

———

I'd treat the man who takes my time
And spend a nickel or a dime,
With courtesy and make him feel
That I was pleased to close the deal
Because tomorrow, who can tell,
He may want stuff I have to sell.
And in that case, then glad he'll be
To spend his dollars all with me.

———

The reason people pass one door
To patronize another store
Is not because the busier place
Has better silks or gloves or lace,
Or cheaper prices, but it lies
In pleasant words and smiling eyes.
The only difference, I believe,
Is in the treatment folks receive.

Three

WOOLWORTH'S, BOND'S, BENSON-RIXON, & BASKINS

After passing Lytton's (on the same side of the street), we reach Woolworth's, the 5 & 10¢ store.

Woolworth's Christmas windows were packed full with everything from holiday wreaths and silver bells for your door to cut-out paper Santa Clauses, Christmas tree lights, and hand blown glass ornaments.

Near the entrance two large cardboard boxes (one for boys, the other for girls), covered with red brick patterned paper to make them look like chimneys, were filled with surprise packages priced, just right, at 25¢. In the 1940s and 1950s Woolworth's counters, throughout the store, were divided into sections made of glass, and the dividers had red price signs clipped to each section.

As a child, one could have found wonderful things, all for a small price. These tiny, inexpensive treasures were always welcomed. For boys there were metal soldiers, marbles, whistles, yo-yos, and tops. For girls there was dollhouse furniture, doll clothes, coloring books, jacks, paper dolls, and pretend makeup accessories, just to mention a few.

As you walked further into the store on the old, creaky, wooden floor, you could see and hear the clerks, calling out for change, to different counters. "Counter number 8 change for $5.00" meant that the clerk needed change in her cash register for that sale.

In the background, you could hear the Christmas music coming from the phonograph. A customer could go to that counter and purchase the 'hit of the week' or a seasonal favorite sung by Rosemary Clooney, Perry Como, Doris Day, or Bing Crosby. Those 78-rpm records cost under a $1.

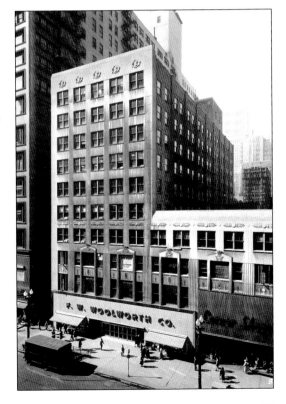

THE WOOLWORTH BUILDING ON STATE STREET. (Photo courtesy of The University of Illinois at Chicago— The Univ. Library Department of Special Collections—Chicago Photograph Collection.)

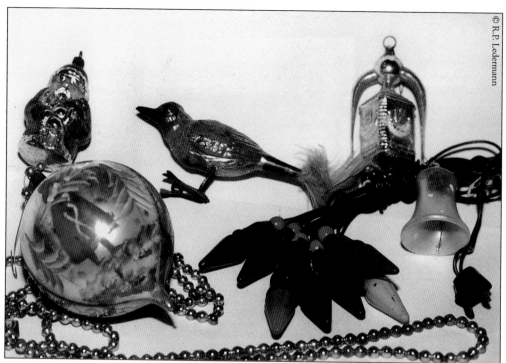

OLD GLASS ORNAMENTS AND CHRISTMAS TREE LIGHTS. In 1880 Frank Woolworth started selling ornaments in his stores and within a decade he was ordering 200,000 annually. These ornaments came from many parts of the world, starting in Germany, Austria, Czechoslovakia, Poland and then Japan. Depending on your budget, in the 1940s you could buy a single hand blown glass ornament for 10¢ or a jumbo one for 79¢. A box of a dozen sold for $1.29. Individual figurines for your Nativity set started at 10¢ each and there were complete sets of Nativity displays starting at $2.98. Then there were the toys—lots and lots of toys.

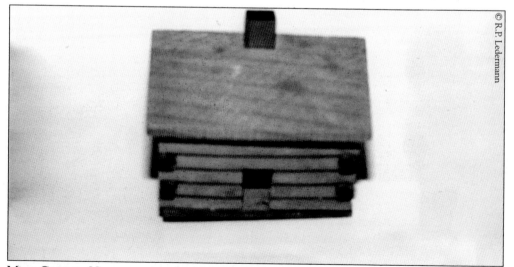

MINI CABINS. Upon entering the store you were immediately drawn to the pine fragrance coming from the miniature log cabins, which burned small incense pellets from within the chimney. They were available in two sizes and sold for 29¢ and 49¢.

28

A STORE FOR EVERYONE. You could purchase literally anything. Blue Willow china sets, Fiesta ware, pins and needles, bakelite jewelry, oil cloth, fishing tackle, inexpensive colognes, talcum powder sets, razor blades, tooth and hair brushes, shoe polish kits, ladies makeup, lipsticks, paper party favors, and the list goes on and on. . . .

SNOWMAN NIGHT-LIGHTS AND PAPER HOUSES. Various paper houses to complete your Christmas village were always available at low prices of 10¢ to 49¢. Snowman night-lights sold at reasonable prices. Shopping for the holidays was a convenience at Woolworth's. Before you left any Woolworth's store, a stop at the candy counter was a must with its penny or bulk candies. Most Woolworth stores also had their own lunch counters. Woolworth's had two store locations on State Street between Jackson and Randolph.

TIN AMUSEMENT. Inexpensive tin wind up toys were popular with any child and gave hours of amusement.

HEART OF SUGAR. Paper candy containers in the shapes of Santa and snowman were a must for stocking stuffers.

BOND CLOTHING STORE BOY'S AD, 1950. On the northwest side of State Street at Jackson, at 234 S. State, Bond's Clothing Store opened its doors in 1949. They carried a medium priced clothing line for the family. 'Santa Claus' could bring your favorite little cowboy, from Bond's, his very own authentic Hopalong Cassidy shirt for only $2.95 in 1950.

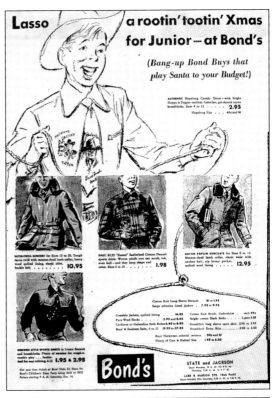

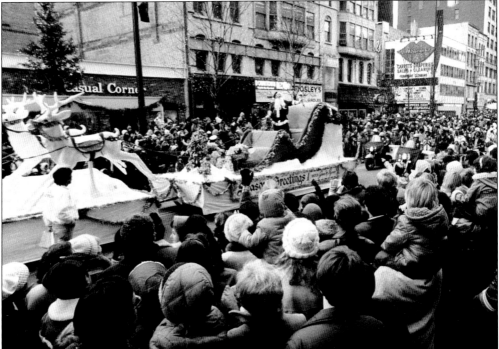

SANTA ON SLEIGH FLOAT IN THE NOVEMBER 30, 1980, CHRISTMAS PARADE. (Photo by David Joel/Chicago—Courtesy of The Greater State Street Council.)

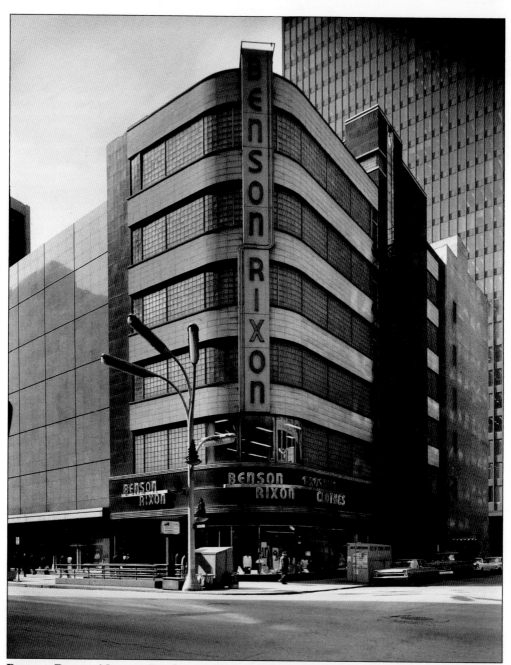

BENSON-RIXON. Next to Bond's was Benson-Rixon, another great clothing store with its fabulous facade of art deco brick glass design. Chicagoans never had a problem finding a clothing store at the south end of State Street near Jackson. On this one street there was a diverse Mecca of five major clothing stores: Rothchild's, Lytton's, Baskins, Bond's, and Benson-Rixon. And just a short distance up the street was Broadstreet's in the Palmer House lobby. (Photo courtesy of The University of Illinois at Chicago—The Univ. Library Department of Special Collections—Chicago Photograph Collection.)

THE FAIR AND MONTGOMERY WARDS

On the northwest corner of State and Adams stood The Fair Store, whose motto was "A Great Store in a Great City."

German born Ernst J. Lehmann founded The Fair Store in 1874-75, in a humble one story building. The store sold mostly household goods including china, pictures, and hardware. The Fair then developed an extensive line of merchandise including furniture, sewing machines, baby buggies, toys, and games for adults. His idea was not to specialize in just apparel and fabrics, but to carry and sell a line of inexpensively priced household items. Lehmann named his store "The Fair," saying "the store was like a fair because it offered many and different things for sale at a cheap price."

In 1890 William Le Baron Jenney and William Mundie built a new, larger store. Throughout this new store more employees were hired to fill the needs of the newly developed departments. Its increased inventory of low priced jewelry, china, and furniture that was readily available to customers helped it to prosper and grow, triggering the 1924 store remodeling.

STATE STREET VIEW WITH THE FAIR STORE IN THE CENTER. (Photo courtesy of The University of Illinois at Chicago—The Univ. Library Department of Special Collections—Chicago Photograph Collection.)

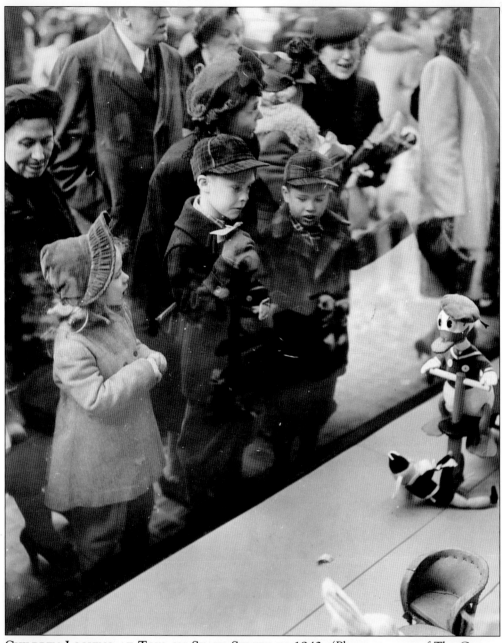

CHILDREN LOOKING AT TOYS ON STATE STREET IN 1943. (Photo courtesy of The Greater State Street Council.)

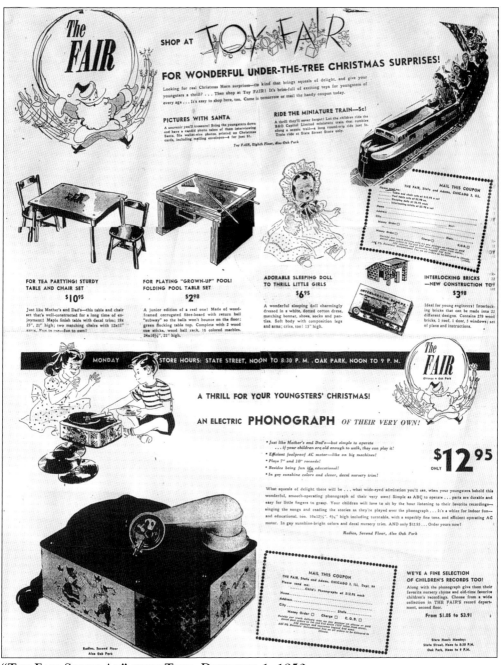

"THE FAIR STORE AD" WITH TOYS, DECEMBER 1, 1950.

As a child, at Christmas time in the 1940s and 50s, you could go to their toy department, called 'The Toyfair' and actually ride a small B&O Railroad train around toy town for 5¢. You could also record your voice onto a small cardboard 78rpm record for the moderate amount of 25¢.

Every year, one of The Fair's large State Street store windows was filled with popular toys of all kinds. There were drums, blocks, dolls, sleds, table games, Lincoln logs, Tinker toys, miniature castles and dollhouses, doctor's and nurse's kits, and baseball gloves and bats. In the middle of all the toys stood an animated Santa with his trusty elves. New, special toys, like the all-metal, sturdy rubber tire 'Radio Special' Flyer wagon, sold for $2.98. 'The Marx Diesel Miniature "Union Pacific" wind up train could also be purchased for $2.98 in December of 1950.

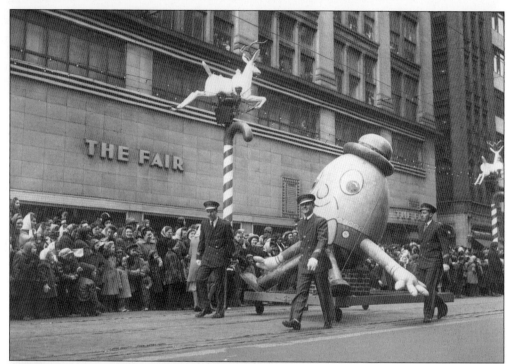

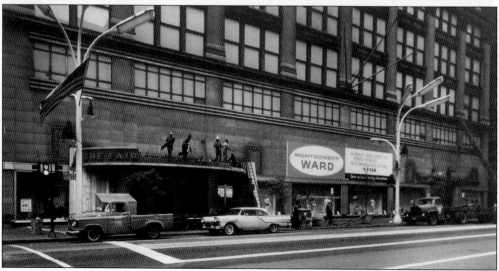

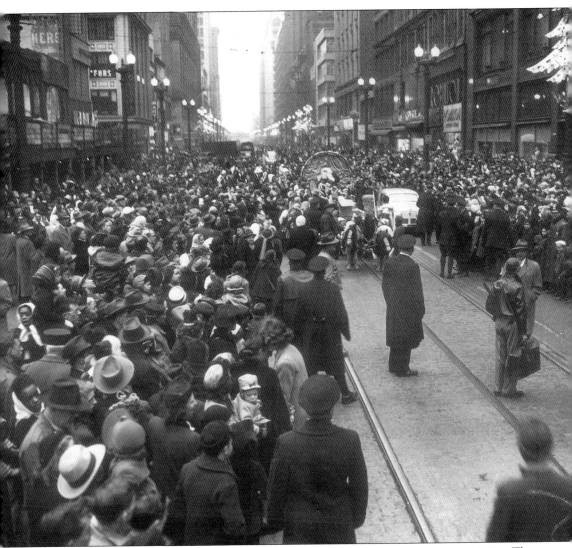

SANTA WITH PONIES IN THE CHRISTMAS PARADE ON STATE STREET IN THE 1940S. The Fair Store closed in the early 1960s when Montgomery Wards took over its 11-story structure. The massive remodeling, both inside and out, of the State and Adams store took two years to complete. The official opening took place on Monday, November 1, 1965. They had re-designed the lower five floors to have wider aisles and larger departmentalized sections for better mass merchandising. The upper floors would be leased for offices. (Photo Ideas Inc./The Greater State Street Council.)

Opposite, Above: A "HUMPTY DUMPTY" BALLOON IN FRONT OF THE FAIR STORE ON STATE STREET IN THE 1949 CHRISTMAS PARADE. (Photo by Acme Newspicture/Courtesy The Greater State Street Council.)

Opposite, Below: THE OLD FAIR STORE MARQUEE COMES DOWN AND THE NEW MONTGOMERY WARDS LOGO GOES UP. (Photo Courtesy of The Chicago Historical Society ICHI—34902 Photographer John McCarthy.)

Aaron Montgomery Ward, the founder of the Ward's family, was born in Chatham, New Jersey, in 1844. He was known as the 'watch dog of the lakefront.' This was because he was the man who fought against developers who wanted to build future structures on Chicago's lakefront. The only building permitted was the Art Institute on Michigan Avenue. We can thank him for his benevolence and wisdom in this fight for helping to preserve the natural beauty of our lakefront. In a newspaper interview he was quoted as saying, "I think there is not another man in Chicago who would have spent the money I have spent in this fight. I fought for the poor people of Chicago, not the millionaires."

Ward started his small mail order and dry goods businesses on north Clark Street in 1872. Within a few years he issued his first catalog and thus began the Montgomery Wards business. Regrettably, Ward passed away from pneumonia in 1913, in Highland Park, Illinois, but his empire lived on. In September of 1963, Montgomery Ward & Company disclosed their plans to the *Chicago Tribune*, saying they would expand and remodel The Fair Store retail operations. The name would be changed to Montgomery Ward & Company. The paper concluded the article stating that "The Fair was highly regarded as one of the earliest in the development of the modern department store on the celebrated thoroughfare known as State Street."

OLDER ITEMS AND GAMES FROM THE PAST, INCLUDING TIDDLY WINKS.

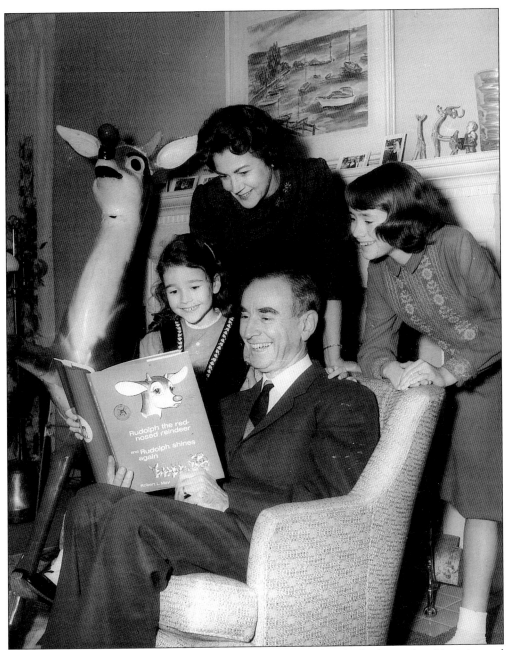

THE MAY FAMILY. Pictured from left to right are Rudolph, Elizabeth, mother Virginia, and Martha May, and Robert L. May, who is reading the 25th Anniversary Edition—1964. During the holiday season throngs of shoppers filled the wide aisles. One of their Christmas windows appeared, as usual, with an extensive amount of toys, but more than that, Wards had presented their own new Christmas character, Rudolph the Red Nosed Reindeer. (Photo courtesy of Robert L. May Company, © 2002 by Robert L. May Company used by permission by the Robert L. May Company.)

ROBERT L. MAY, the creator and copyright holder of Rudolph, worked for Wards. He was asked by Wards executives to write a Christmas theme to be used as a toy department premium.

He began writing about Rollo the reindeer, who had bright shiny eyes, then changed the name to Reginald, before finally settling on Rudolph. It was said that "May would read the story to his children to get their reactions."

Barbara Lewis, May's oldest daughter, recalls with fond memories these thoughts of her father, who read to her early drafts of the Rudolph manuscript.

"In the early 1940s, my father carpooled off to downtown Montgomery Wards from our Evanston apartment five mornings a week. On Saturday mornings—a standard part of the work week in those days—he'd drive his own car, a 1941 coral-pink Buick, and sometimes I got to go with him. I felt pretty important as the daughter of the man who'd created Rudolph. Each weekday Dad prepared a floppy peanut-butter sandwich to eat in the car for breakfast on his way to Wards. I imagined him squinched into the car with four other men, chomping away, filling the tiny airspace with peanut butter fumes. I just hoped those other guys were partial to peanuts. All of dad's cars were in the red family, by the way. All General Motors cars—Buicks or Oldsmobiles—and all of them one shade or another of red."

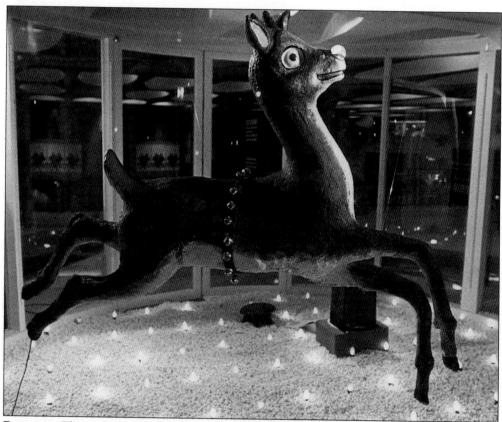

RUDOLPH. This replica of Rudolph the Red Nosed Reindeer, in the Hopkins Center Rotunda at Dartmouth College, was given to the school by Robert L. May (class of 1926). In 1949 Johnny Marks wrote and published the song "Rudolph the Red-Nosed Reindeer." Gene Autry was asked by Marks to record it, and it turned out to be Autry's biggest selling record ever. After Autry's success with the song, other recording artists like Perry Como, Bing Crosby, Guy Lombardo, and Lawrence Welk also recorded the song. (Photo courtesy of Robert L. May Company, © 2002 by Robert L. May Company used by permission by the Robert L. May Company.)

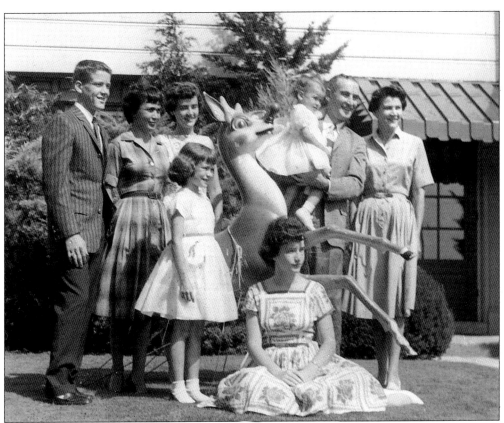

THE MAYS. Pictured from left to right are son Christopher, daughter Barbara Lewis, daughter Joanna May, daughter Elizabeth Decker being held by Robert L. May, Virginia May (center row) daughter Martha May, Rudolph, and seated, daughter Virginia Herz. (Photo courtesy of Robert L. May Company, © 2002 by Robert L. May Company used by permission by the Robert L. May Company.)

Robert L. May graduated Phi Beta Kappa from Dartmouth College in 1926 and started working at Montgomery Wards in 1936. The poem with its illustrations by staff artist Denver Gillen was printed in 1939 as a booklet and given to 2.4 million children. After World War II, in 1946, the booklet was re-printed and another 3.6 million copies were distributed. He donated the original 32 page Rudolph manuscript to the Baker Library at Dartmouth in 1958. After Robert L. May's passing the family donated the Rudolph collection to Dartmouth College in memory of their father, who created a wonderful Christmas character for the children of Chicago. The display was housed at the Robert L. May Collection at Dartmouth College in Hanover, New Hampshire, as of 1995.

Chicago lost its Montgomery Ward and Company 11-story State Street flagship store at the end of the 1984 Christmas shopping season. The store was closed in January of 1985 and the building demolished that June.

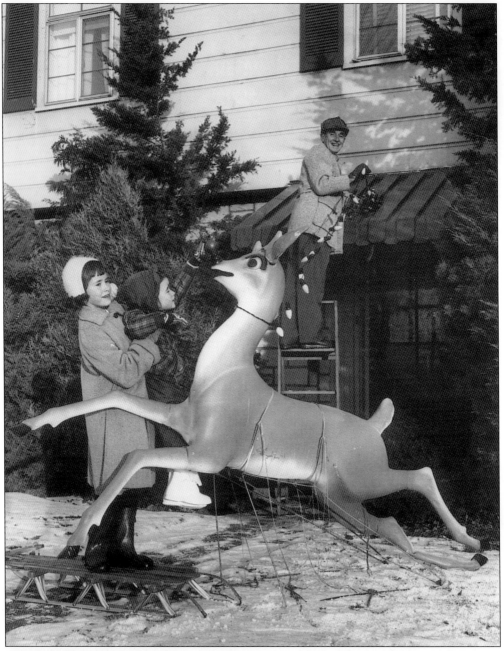

MARTHA, ELIZABETH, RUDOLPH, AND ROBERT L. MAY. (Photo courtesy of Robert L. May Company, © 2002 by Robert L. May Company used by permission by the Robert L. May Company.)

Five

THE PALMER HOUSE
BROADSTREET'S AND PEACOCK'S

Traveling just north of Montgomery Wards, with a light snow beginning to fall, we reach The Palmer House Hilton Hotel. Just to the right of the hotel's State Street entrance was Broadstreet's. This clothing shop carried upscale clothing for visiting guests of the hotel and for their Chicago area customers who wanted something more.

The Palmer House Hilton, located at 17 E. Monroe Street, was and still is a Chicago treasure with its magnificent lobby.

Entering this famous 'Queen of Hotels,' we remember that this hotel is the oldest continually operating hotel in the country. The first building (located across the street on the west) opened September 26, 1871, with 225 rooms at a cost of $300,000. Those were the days when cable cars instead of subways circled the "Loop." Unfortunately, thirteen days later it burned to the ground in the Great Chicago Fire. The hotel was a smoldering heap of ruins. Undaunted by the destruction of his entire fortune, Palmer was determined to relocate across the street at what has become its permanent location. It is written that "in the few precious moments before the flames reached the Palmer House, Chicago's pioneer architect, John Mills Van Osdel, carried all his construction plans and records to the hotel's basement and dug a pit, which he covered over with two feet of sand and damp clay. He not only preserved the documents, but also devised a method of fireproofing with clay tile that was used for many years thereafter."

A second 'fireproof' Palmer House was completed only a short two years later in 1873. Its owner, Potter Palmer, a merchant and real estate entrepreneur, meticulously supervised the new 700-room hotel's construction. By 1875, it was said the hotel was the first to provide its guests with electric lighting, telephones, and elevators. A bar room with an 85-foot bar became the drinking center of Chicago. Palmer was said to have made a wager with his business associates "that if they were to build a fire in the center of one of rooms, and close up the door for an hour, the fire would not extend beyond that room." No one ever took him up on the bet.

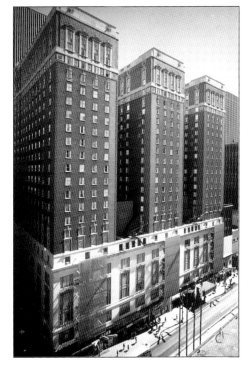

THE PALMER HOUSE HILTON. The Palmer House promotional materials describe the beautiful hotel as, "Located in the heart of downtown Chicago, The Palmer House Hilton is Chicago's most ideally located hotel. The Best of the City of Chicago was built around The Palmer House Hilton." (Photo courtesy of The Palmer House Hilton Hotel.)

Potter Palmer literally bought and developed State Street. He raised the street level for the downtown area. The Palmer House Hilton means "Chicago" to the travelers of the globe. Palmer planned and created Lake Shore Drive north, when he built his family's mansion at what is now 1350 N. Lake Shore Drive, pushing Lake Michigan back. His wife, Bertha Palmer, the queen of social Chicago, was the driving force behind the 1893 Colombian Exposition.

The Palmer House began an extensive re-building again from 1925 through 1927. Sections of the hotel were demolished in stages, and the first half of the new part opened in 1926. By the time the second half opened in 1927, it had 24 floors with 2250 rooms at a cost of more than $20 million. The upholstered furniture, made of the finest velvet, was supplied by Carson, Pirie, Scott & Company.

Gentlemen flocked to The Palmer House barbershop, mainly to see the floor, inlaid with silver dollars. Many years later a new treasury law prohibited the use of United States minted coins and the hotel substituted them with Mexican silver dollars.

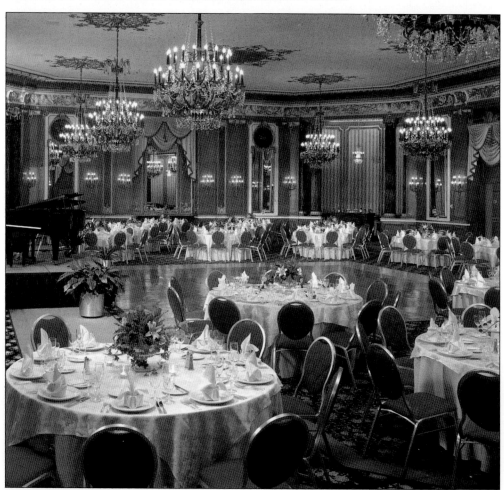

RED LACQUER BALLROOM OF THE PALMER HOUSE HILTON HOTEL. "Reminiscent of a ballroom of a king's palace, the Red Lacquer Ballroom, with its enameled red walls and lustrous chandeliers with garnet drops, provides the perfect setting for parties befitting royalty. Completely renovated and returned to its original grandeur, the Red Lacquer Ballroom was selected by the *Chicago Tribune* as one of Chicago's architectural jewels." This is again from the hotel's own quite accurate description. (Photo courtesy of The Palmer House Hilton.)

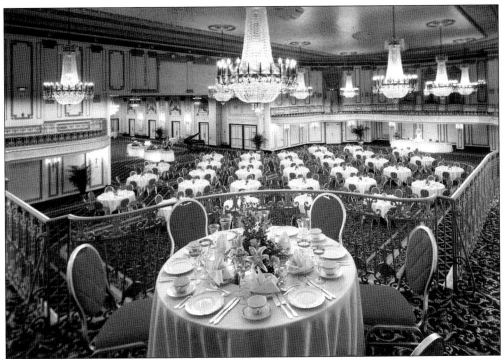

GRAND BALLROOM. The Palmer House could claim "Presidents, Kings, heads of state, dignitaries and countless celebrities have been entertained in style in The Palmer House Hilton's historic Grand Ballroom." (Photo courtesy of The Palmer House Hilton.)

The street floor is an upscale commercial arcade lined with a variety of retail shops. Entering the main polished brass Palmer House Hilton doors at 119 N. State Street, there is a center escalator bank which leads up to the magnificent lobby and mezzanine. One can certainly appreciate the dazzling main *fin de siecle* hall with its splendid space. On the high ceiling is a collection of 21 canvas paintings by Louis Pierre Rigal. Elaborate candelabras and beautiful crystal chandeliers illuminate the entire lobby. The area is tastefully furnished with authentically reproduced fabrics and carpeting. In the middle of this wonderful space, during the holidays, stands an enormous Christmas tree surrounded by a miniature toy train.

The decorative pilasters and the massive marble clock above the doors lead into the grand staircase that leads to the famous 'Empire Room,' at one time the main dining room for the hotel. Its mirrored walls are decorated with gold reliefs of Napoleon and Josephine. (See color insert.)

One is reminded of all the celebrities who have entertained in this room, such as Sophie Tucker, Jimmy Durante, John Davidson, Carol Channing, Nat King Cole, Pearl Bailey, Tony Bennett, Ted Lewis, Jack Benny, Hildegarde, Maurice Chevalier, and so many more. Being in that elaborate room, during Christmas time especially, gave one an auspicious feeling. The black, green, and gold décor was surrounded by mirrored doors with a small stage where the stars entertained.

The guest books of The Palmer House read like a who's who of famous people. Past presidents and other historical figures like Ulysses S. Grant, James Garfield, Grover Cleveland, William Jennings Bryan, William McKinley, Rudyard Kipling, Charles Dickens, Oscar Wilde, Mark Twain, and Buffalo Bill Cody all stayed there.

This great hotel is still thriving, and has more than 1600 rooms and nearly 100 suites, but now is part of the Hilton Hotel chain, and the Empire Room is no longer a show place/dinner club, but is used for special, glamorous, private occasions. On December 10, 1945, Conrad N. Hilton bought The Palmer House for $20 million, and changed the name to The Palmer House Hilton.

As we leave The Palmer House Hilton, on the southeast corner of Monroe and State was the majestic C.D. Peacock's, Chicago's oldest retail jeweler. It had been built as part of the Palmer House complex in 1927. Founder Elijah Peacock started his trade in Chicago in 1837. Peacock's sold the store to the Gordan Jewelry Corporation in 1990 and, shortly thereafter, left State Street.

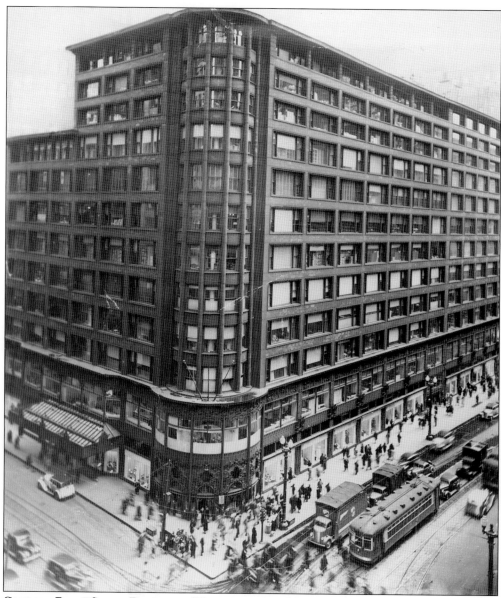

CARSON, PIRIE, SCOTT BUILDING. (Photo courtesy of Carson, Pirie, Scott.)

Six

CARSON, PIRIE, SCOTT AND BOSTON STORE

Approaching the intersection of State and Madison, known at 'the world's busiest corner,' we are at Carson, Pirie, Scott and Company, an architectural landmark building, built by the famed Louis H. Sullivan. The gigantic ornamental ironwork compliments the iron facade around the windows. The incredible marquee facing Madison Street, the impressive vestibule with its bold columns at the entranceway, and the special attention to the interior stairwells all speak volumes of architectural grandeur.

Way back in 1854, Samuel Carson and John T. Pirie were detained coming to America from northern Ireland because the ship they sailed on, The Philadelphia, was wrecked off Cape Race, Newfoundland. They finally settled in southern Illinois, working in the small towns of Peru and LaSalle, and then opening a small dry goods shop in Amboy, Illinois. Within a few years Carson had enough security to send for his (bride to be) partner's sister, Elizabeth Pirie, all the way from Belfast, Ireland. Soon after, John E. Scott, a good family friend, came to America to work for them as an errand boy, but he quickly became their partner.

Carson, Pirie, Scott and Company moved to Chicago and settled in the State and Madison location where they leased the building for years until 1955 when they finally purchased it as their flagship store.

CARSON'S HIDDEN STAIRWELL WITH CHANDELIER IN THE LATE 1950S. Carson's stairwell and crystal chandelier were removed in the 1960s. (Photo courtesy of Carson, Pirie, Scott.)

MAIN AISLE OF CARSON'S WITH MASSIVE COLUMNS AND LOUIS SULLIVAN DECORATIVE CAPITALS WITH CHRISTMAS TREES AT BASE WITH NEW INDIRECT LIGHTING ON CEILINGS. (Photo courtesy of Carson, Pirie, Scott.)

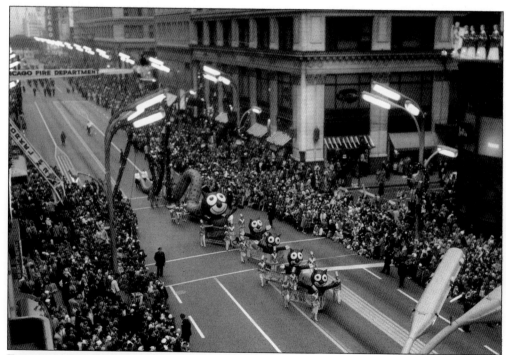

FELIX THE CAT BALLOON FLOAT ON STATE STREET. Just passing Mandel Brothers, the 1962 Christmas Parade approaches the Carson, Pirie, Scott and Company department store at State and Madison. Note the choir boys on top of the rotunda in the upper right corner. (Photo courtesy of Town Country Photographers/The Greater State Street Council.)

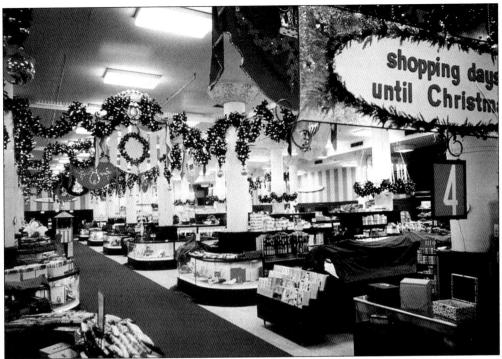

CARSON'S MAIN AISLE IN 1958, THE NOTIONS DEPARTMENT. (Photo courtesy of Carson, Pirie, Scott.)

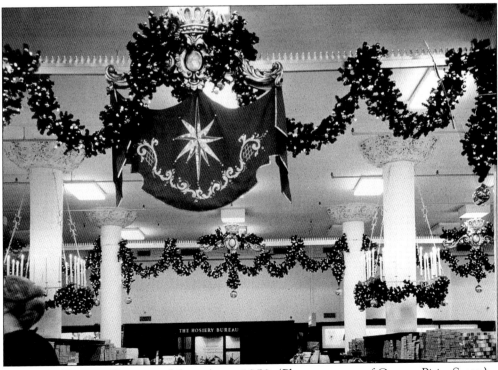

CARSON'S HOSIERY BUREAU—MAIN AISLE 1958. (Photo courtesy of Carson, Pirie, Scott.)

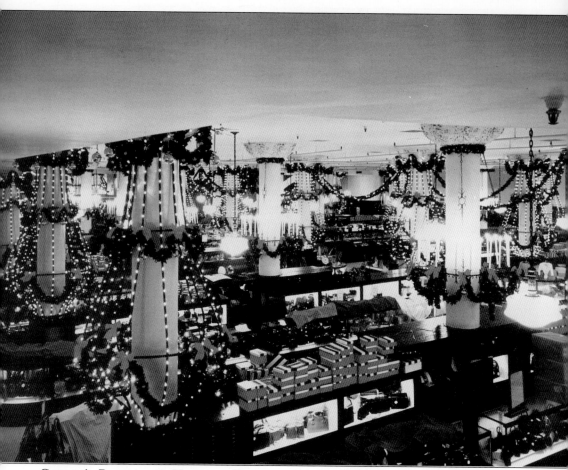

CARSON'S PURSES AND HANDBAG DEPARTMENT IN THE MAIN AISLE. (Photo courtesy of Carson, Pirie, Scott.)

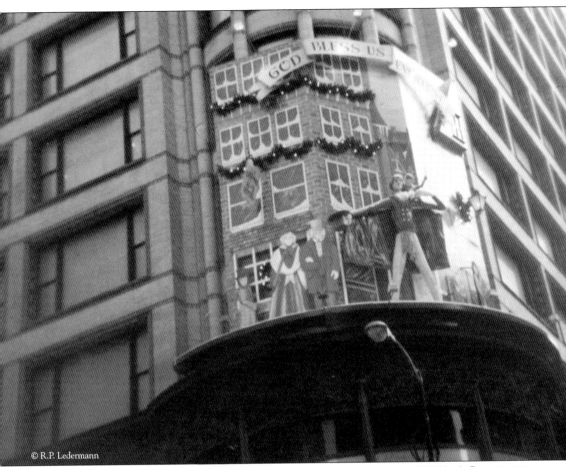

OUTSIDE PHOTO OF CARSON'S ROTUNDA WITH LIFELIKE FIGURES FROM 1977'S *A CHRISTMAS CAROL*. Bob Cratchit is holding Tiny Tim. Carson's Christmas windows were always popular and would carry a theme with animated figures for the amusement of the children. Perhaps a village of bunnies was preparing for Christmas. And once, Carson's had *The Nutcracker* grace their windows with its story. Another time the windows had the legendary Charles Dickens classic *A Christmas Carol*, complete with Scrooge, Tiny Tim, and all the ghosts.

In 1977, above the rotunda at the corner of State and Madison, Carson's had a giant display depicting Dickens' *A Christmas Carol* that connected to the story they were telling in the windows. This would give the passerby a preview, from a distance, of what was in store for them. These Christmas windows and their captions can be seen in the following pages. (All *Christmas Carol* photo caption text is courtesy of Carson, Pirie, Scott.)

A Christmas Carol

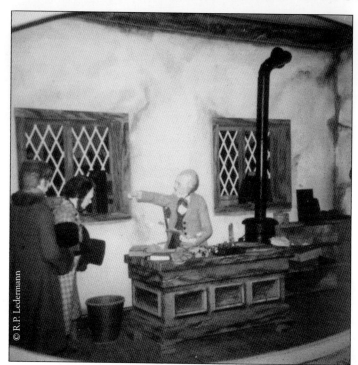

©R.P. Ledermann

"Once upon a time, very long ago in London, there was a miserly man named Ebenezer Scrooge, who employed a poor clerk named Bob Cratchit. Bob worked in the chill of Scrooge's counting house. Sometimes his fingers were so stiff with cold he could scarcely write a cipher. One day, it was the day before Christmas, two gentlemen came soliciting a donation from Scrooge. 'Bah Humbug' said Scrooge! 'What shall I put you down for?' 'Nothing' Scrooge replied."

"Afterward, out into the cold bleak weather went Scrooge, and at length, to the door of his dreary home. He was about to unlock the door, when suddenly, a face appeared in the place of the door knocker. It was the face of his long-dead business partner, Jacob Marley. Scrooge saw not a knocker, but Marley's face." (Photo courtesy of Carson, Pirie, Scott.)

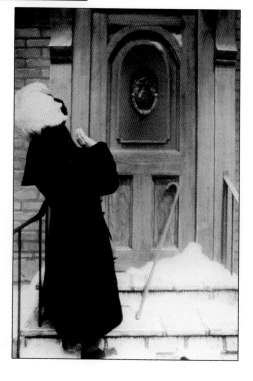

"When inside the house, readying for bed, in his bedchamber, Scrooge was even more startled to see the ghost of old Marley again, in chains. He tried to dismiss the specter, but the voice of Jacob Marley informed him that he would be visited by three spirits; The Ghost of Christmas Past, The Ghost of Christmas Present and The Ghost of Christmas Yet to come. 'In life I was your partner, Jacob Marley. You will be haunted,' resumed the ghost, 'by three spirits.'"

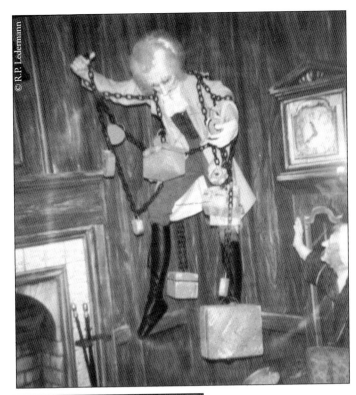

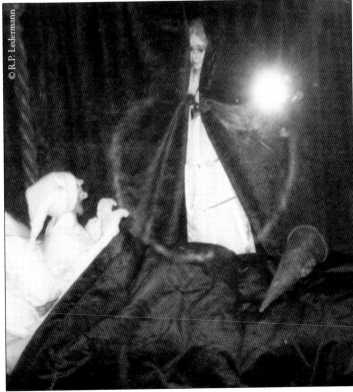

"When the first of the three spirits appeared, he showed Scrooge scenes from the past. 'I'm the ghost of Christmas Past. Your past.'"

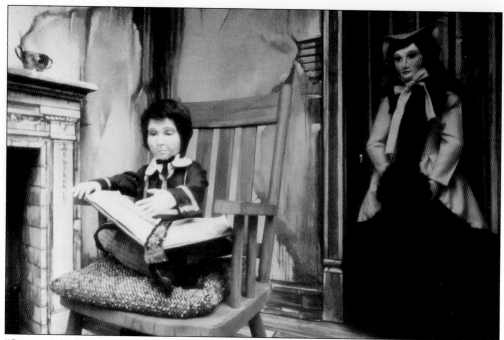

"Scrooge's little sister came to take him home from boarding school for Christmas. 'I have come to bring you home, dear brother!'" (Photo courtesy of Carson, Pirie, Scott.)

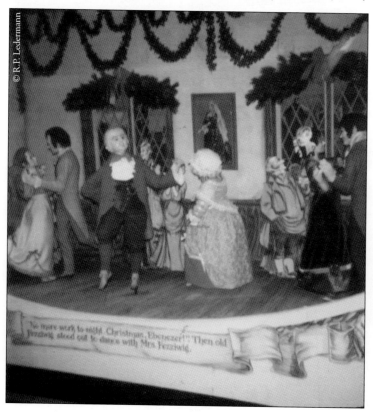

©R.P. Ledermann

"Scrooge visits his kindly old employer named Fizziwig and sees the happy Christmas party he once knew as a young man. 'No more work to-night. Merry Christmas Ebenezer!' Then old Fizziwig stood out to dance with Mrs. Fizziwig."

"The second of the three spirits appeared, The Spirit of Christmas Present. 'Ghost of Christmas present,' said Scrooge submissively, 'conduct me where you will.'"

© R.P. Ledermann

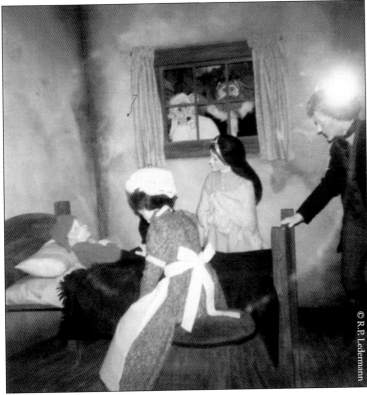

© R.P. Ledermann

"The Spirit of Christmas Present shows Scrooge the poor Cratchit family, giving him a glimpse of Bob Cratchit and his beloved son Tiny Tim, who is ill. 'Spirit, tell me if Tiny Tim will live.'"

"The Ghost of Christmas yet to come showed Scrooge what might be. Alas, an empty chair and the abandoned crutch of Tiny Tim if things continued the way they had been for the Cratchit family and their sickly little son. 'I see a vacant seat,' replied the Ghost of Christmas Yet to come, 'and a crutch without an owner.'"

"And...moving still further into the future, the ghost showed him the tombstone of one Ebenezer Scrooge. Yes, Scrooge's own grave. 'Spirit! Hear me! I am not the man I was. I will honour Christmas in my heart, and try to keep it all the year.'"

"Oh, but it was only a dream. Scrooge awakened thrashing about on his own bed. And what day was it? Why, Christmas Day, of course. He threw open the window and whooped a 'Hello' to the boy in the street asking him to fetch the prize turkey that was hanging in the poulterers' window and take it to Bob Cratchit's. 'It's Christmas Day! I haven't missed it. Do you know whether they've sold the prize turkey that was hanging up at the poulterers'?'" (Photo courtesy of Carson, Pirie, Scott.)

"Scrooge set out for Bob Cratchit's house only to run into the gentlemen who had been refused a donation just the day before. He took the gentleman's hand warmly and gave him a handsome sum of charity. 'Not a farthing less,' said Scrooge. 'A Merry Christmas to you sir!'"

"At Bob Cratchit's door, Scrooge paused and as Bob opened the door, Scrooge wondered if he would let him in. 'Hello!' growled Scrooge in his accustomed voice as near as he could feign it."

"Let him in, indeed! He did! And no Christmas was ever merrier! No family was ever happier! And as Tiny Tim observed, 'God bless us, everyone!'"

58

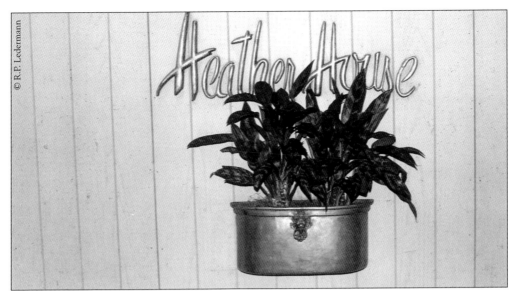

HEATHER HOUSE SIGN WITH BRASS CONTAINER. After viewing the windows, shoppers could elect to stop for lunch at one of Carson's fine restaurants. Two of the favorite restaurants were on the eighth floor. The Men's Grill that featured a daily lunch special had dark wood paneling and red leather captain's chairs. The other side of the floor was home to Carson's Heather House Restaurant, which opened to the public in September 1959. The Heather House occupied the space that was formerly the Maypool and Georgian rooms, which seated 500 guests. The highlight of the room was the 54 foot hand painted mural, in soft tones of greens and beige, showing a panoramic view of Edinburgh, Scotland, by A.R. Gordon (Chicago 1959).

CARSON'S HEATHER HOUSE RESTAURANT MENU.

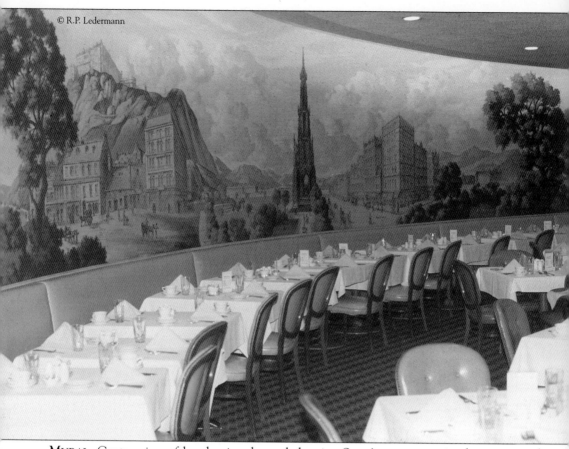

© R.P. Ledermann

MURAL. Center view of hand painted mural showing Scott's monument in the center with Edinburgh Castle on the hilltop at upper left. (Also see color insert.)

There was also a 12-foot square stage for fashion shows and a large curtain that could divide the room into a tea time area. John T. Pirie Jr. said to the *Chicago Daily News* on September 21, 1959, "That increased facilities intended to give customers the finest services." The side wall had pressed heather sprigs imbedded into frosted panes of Lucite. A lunch time specialty was Carson's legendary buffet with freshly baked, sticky, cinnamon buns. Sadly, in May of 1988, this beautiful restaurant closed and was demolished the following year to make a computer room and later on an employees' lunchroom. Carson, Pirie, Scott and Company, one of the last Chicago major independent department store chains, agreed to be sold to the P.A. Bergner and Company, another Midwestern department store chain.

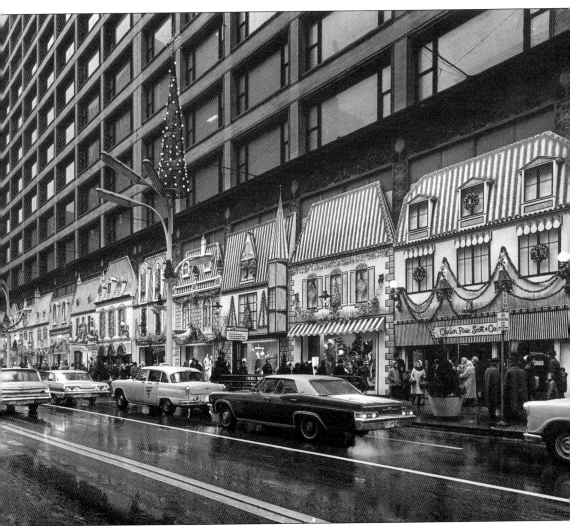

STATE STREET. Looking north on State Street towards Madison, the Carson's Christmas windows of the 1960s depicted various facades of Christmas shops. (Photo courtesy of Carson, Pirie, Scott and Company.)

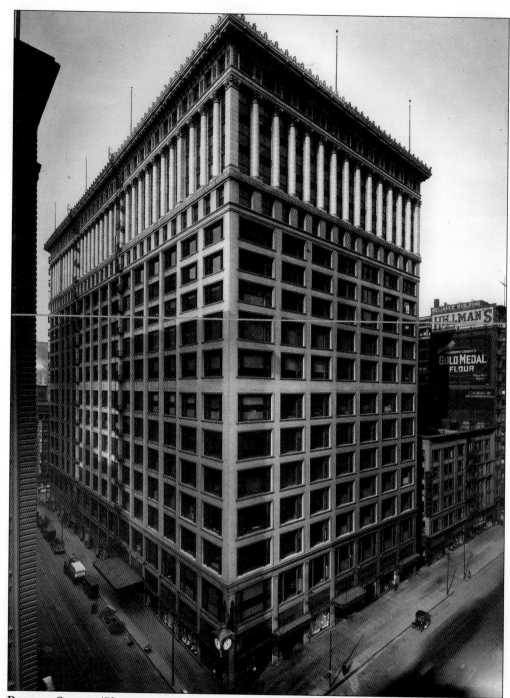

BOSTON STORE. (Photo courtesy The Chicago Historical Society ICHI—30707 Chicago IL. Photographer unknown.)

Opposite: **SUPERMAN BALLOON IN THE CHRISTMAS PARADE OF 1949.** Mandel Brothers/ Wieboldt's Department Store can be seen on the right and the Boston Store across on the left. (Photo by Acme Newspictures/The Greater State Street Council.)

The Boston Store was located on the northwest corner of Madison and State Street. The 17-story building was built in 1915 by Holbird & Roche, predecessor of today's Holabird & Root, replacing the old six story Boston Store that was founded in 1873 and was housed in the lower floors of the old Chaplain Building. The *Chicago Daily News* of June 7, 1976, asks about a curious mystery of the Boston Store, for which we still have no answer, "Why did the brothers, Charles and Edward Partridge of Buffalo, New York, who came to Chicago, call their store 'The Boston Store'?"

In the 1920s the Boston Store was said to have had a deep vestibule at its main entrance, into which a show window would rise at night when the store was closed, to display existing current wares to the nighttime crowds.

The store's later owner was Charles Netcher, who had been a young clerk for the two brothers. He operated the store until his death, when it was taken over briefly by his wife, Mrs. Mollie Netcher Newbury.

After 1923 the Boston Store had its second highest annual sales record of $33 million, but sales began to dramatically shrink. Unfortunately, the store went through several bank holdings and securities until the 1948 liquidation sale of the new Boston Store. This passing represented the first major change in the big State Street department store line-up in many years.

According to a 1948 article in the *Chicago Tribune*, the liquidation sale lasted one month, and brought back many old-time customers for final sales. It was estimated that four million dollars worth of stock was sold in the liquidation sale. On May 23, 2001, Sears re-opened its newest store in this building's location.

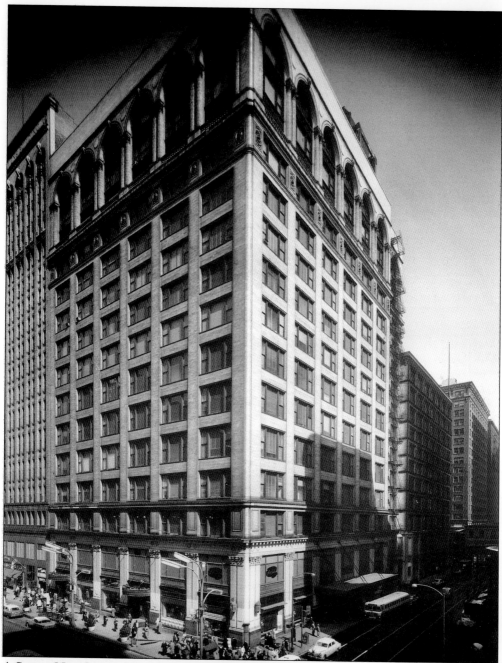

A SMART NEW STORE. Mandel Brothers Department Store was located at the northeast corner of State and Madison, with a heavy, ornate marquee over its doorways. Mandel's motto was, "A smart new store. . .A fine old name." Emmanuel, Leon and Simon Mandel founded Mandel Brothers in 1865. (Courtesy of University of Illinois at Chicago—The Univ. Library—Department of Special Collections—Chicago Photographic Collection.)

UNCLE MISTLETOE FIGURE USED ON TOP THE GREAT TREE IN THE WALNUT ROOM OF MARSHALL FIELD'S IN THE 1950S AND BEYOND.

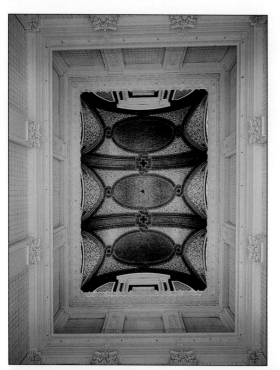

THE FAMOUS LOUIS COMFORT TIFFANY DOME AT MARSHALL FIELD'S. (Photo courtesy of Marshall Field's.)

MARSHALL FIELD'S MAIN AISLE WITH GARLAND REACHING UP TO THE TIFFANY DOMED CEILING IN THE 1980s. (Photo courtesy of Marshall Field's.)

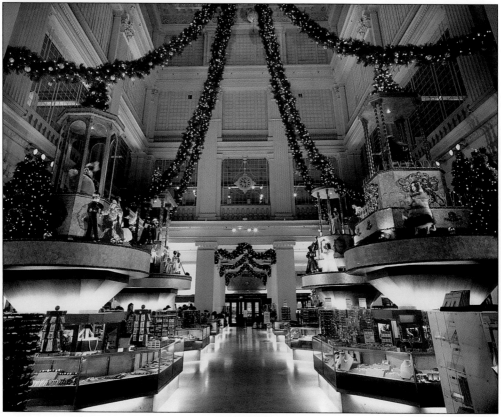

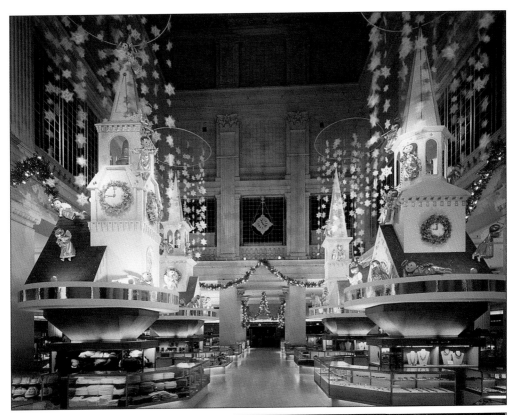

MARSHALL FIELD'S MAIN AISLE OF
1980 WITH WHITE CHURCHES WITH
STEEPLES AND CASCADING WHITE
SNOWFLAKES. (Photo courtesy of
Marshall Field's.)

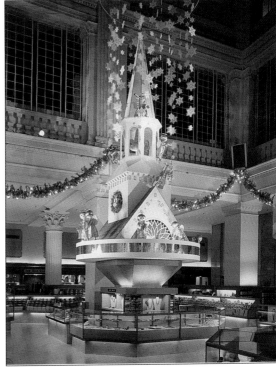

CLOSE-UP OF ONE OF THE WHITE
CHURCHES. All were hand crafted in
Field's own carpenter shop. (Photo
courtesy of Marshall Field's.)

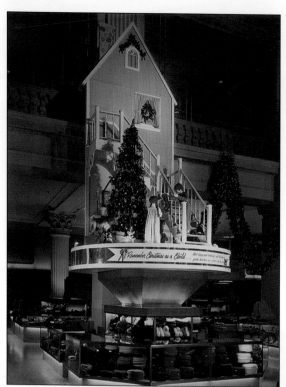

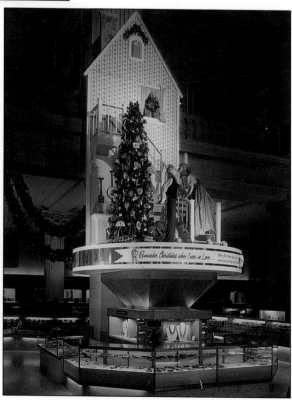

CHRISTMASES REMEMBERED SERIES
1979— 'ADULT' MAIN AISLE.
(Photo courtesy of Marshall Field's.)

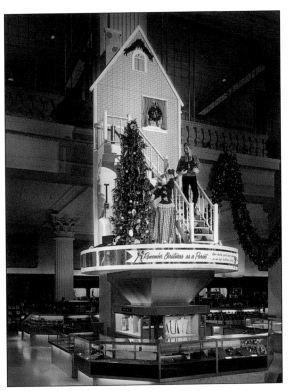

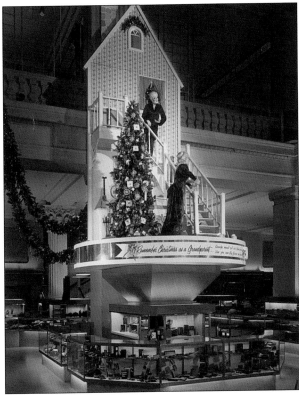

CHRISTMASES REMEMBERED
SERIES 1979—'SENIORS' MAIN
AISLE. (Photo courtesy of
Marshall Field's.)

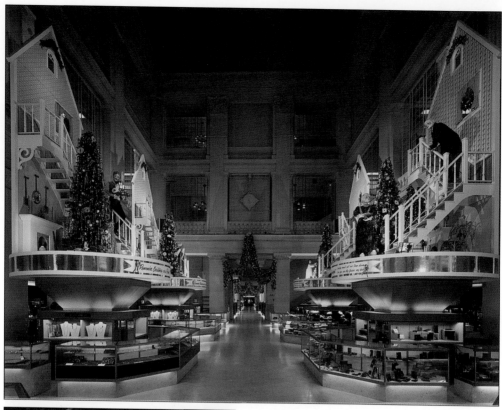

FULL VIEW OF CHRISTMASES REMEMBERED 1979, THE MAIN AISLE WITH ALL FOUR DEPICTIONS OF THE STAGES IN LIFE. All of the scenes were created in the carpenter shop. The clothing on the papiér-mache figures was hand made in the studio as were the ornaments on the trees. (Photo courtesy of Marshall Field's.)

MARSHALL FIELD'S CHRISTMAS DECORATIONS IN MAIN AISLE IN 1973. (Photo courtesy of Marshall Field's.)

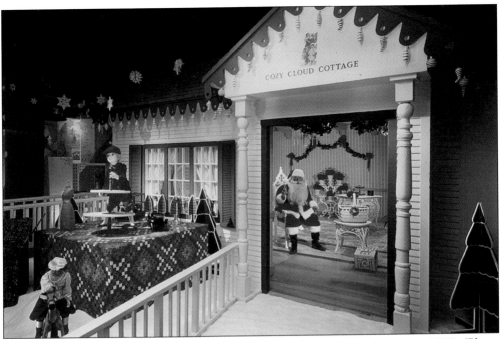

EXTERIOR VIEW OF COZY CLOUD COTTAGE WITH SANTA IN ARCHWAY IN 1975. (Photo courtesy of Marshall Field's.)

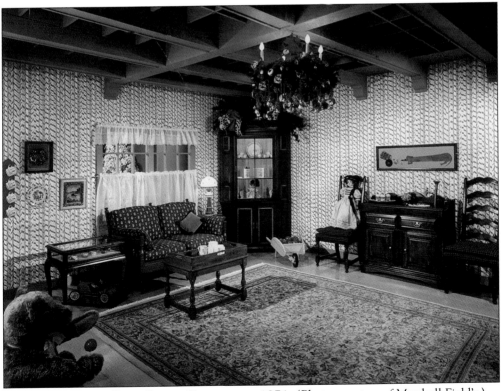

INTERIOR VIEW OF COZY CLOUD COTTAGE OF 1971. (Photo courtesy of Marshall Field's.)

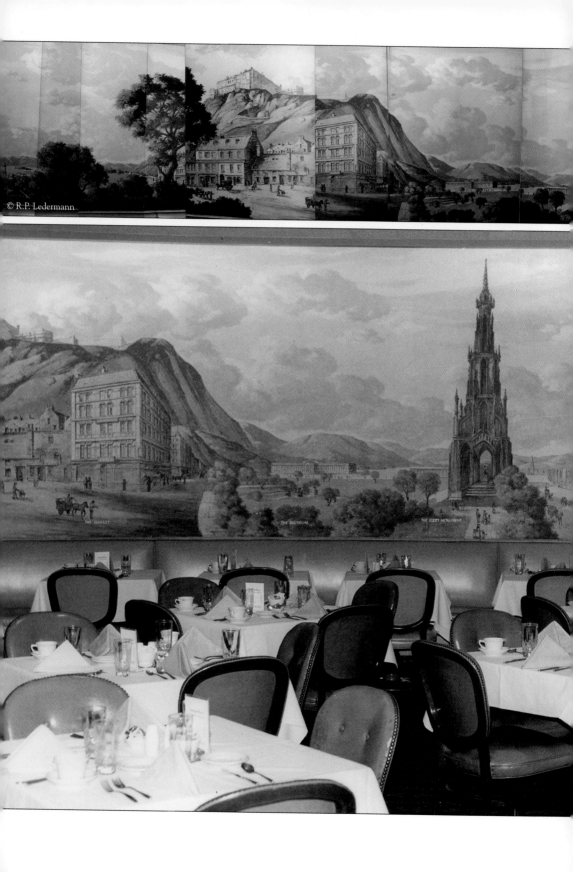

© R.P. Ledermann

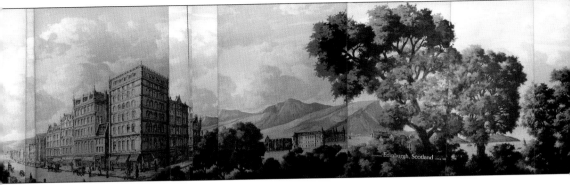

A PANORAMIC VIEW PHOTO OF THE CARSON, PIRIE, SCOTT & COMPANY "HEATHER HOUSE" MURAL OF EDINBURGH, SCOTLAND, BY A.R. GORDON PAINTED IN CHICAGO IN 1959. Looking from left to right…"View from the Dean Bridge…Above Edinburgh Castle…The Market…The Museum…The Scotts Monument…Princes Street…Holy Rood Palace…Firth of Forth."

CARSON, PIRIE, SCOTT & COMPANY'S "HEATHER HOUSE RESTAURANT" WITH THE MURAL IN THE BACKGROUND.

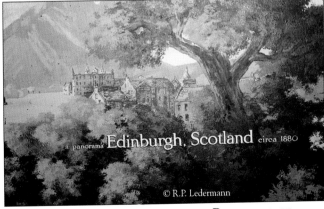

A.R. GORDON 1959 CHICAGO AND A PANORAMA OF EDINBURGH, SCOTLAND, c. 1880.

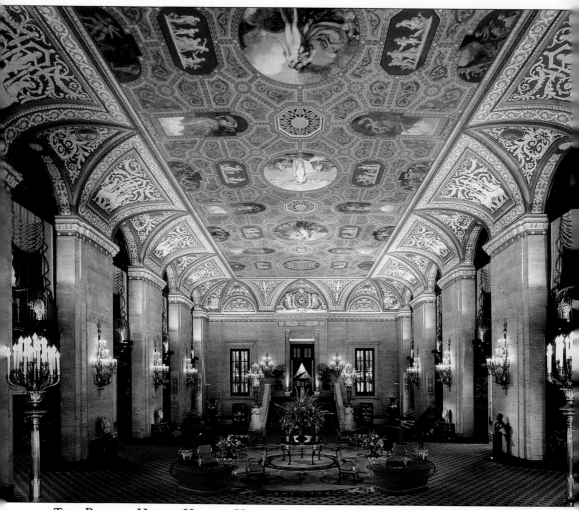

THE PALMER HOUSE HILTON HOTEL LOBBY WITH THE FAMOUS EMPIRE ROOM IN BACKGROUND. Note in the center on either side of the stairway a 'Winged Golden Angel' stands guard resting on solid marble bases. The angels are made up of bronze ormolu and are covered in a layer of 24K gold. Each angel weighs approximately 2 tons. They were designed by Louis Comfort Tiffany and are the largest such sculptures Tiffany ever created. (Photo courtesy of The Palmer House Hilton.)

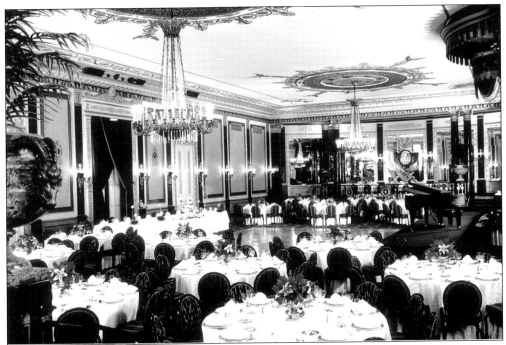

PALMER HOUSE HILTON'S "FAMOUS EMPIRE ROOM." (Photo courtesy of The Palmer House Hilton.)

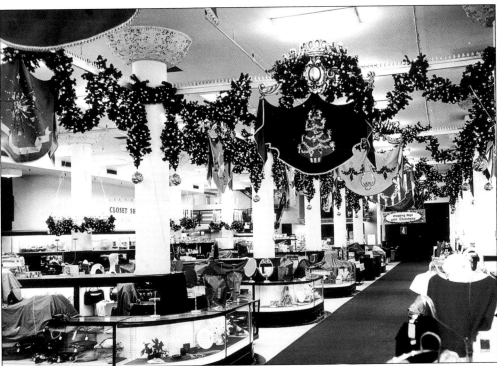

CARSON, PIRIE, SCOTT'S MAIN FLOOR WITH LADIES ACCESSORIES DEPARTMENT IN 1958. (Photo courtesy of Carson, Pirie, Scott.)

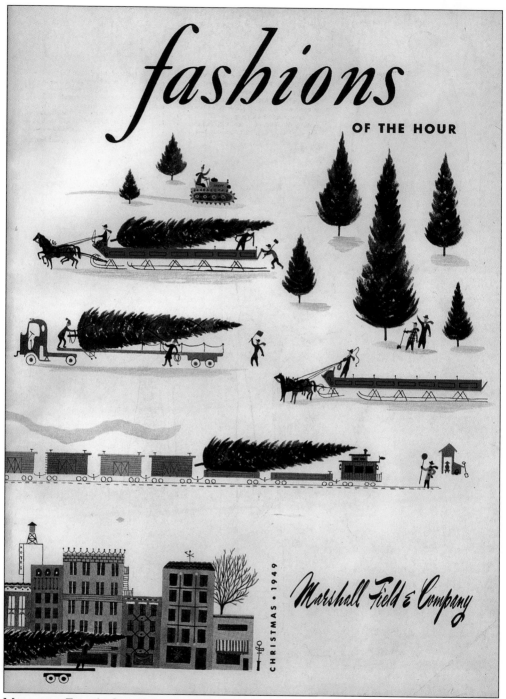

MARSHALL FIELD'S CATALOG OF 1949, "FASHIONS OF THE HOUR." Front cover illustrating how the Great Tree comes to Field's. (Photo courtesy of Marshall Field's.)

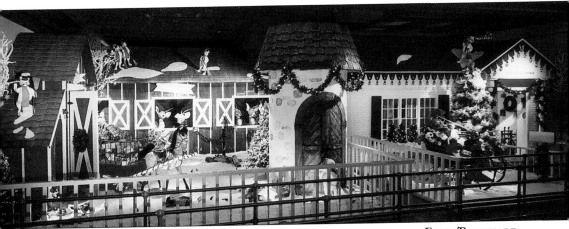

EXTERIOR VIEW OF MARSHALL FIELD'S COZY CLOUD COTTAGE WITH A FARM/BARNYARD THEME. (Photo courtesy of Marshall Field's.)

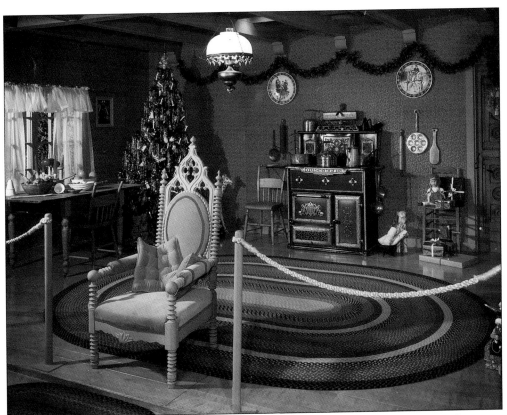

INTERIOR VIEW OF COZY CLOUD COTTAGE WITH SANTA'S CHAIR AND REPLICA OF ANTIQUE STOVE IN THE BACKGROUND AND AUTHENTIC BLUE DELFT PLATES ON THE BACK WALL. (Photo courtesy of Marshall Field's.)

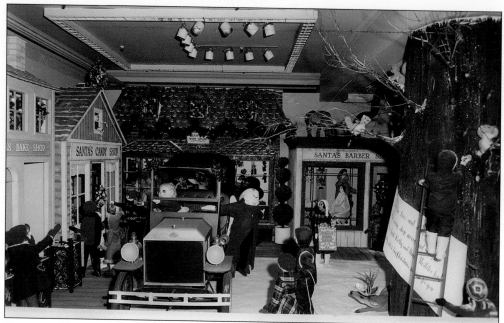

EXTERIOR VIEW OF COZY CLOUD COTTAGE FROM 1972 WITH OLD, VINTAGE AUTOMOBILE AND AUNT HOLLY AND UNCLE MISTLETOE. (Photo courtesy of Marshall Field's.)

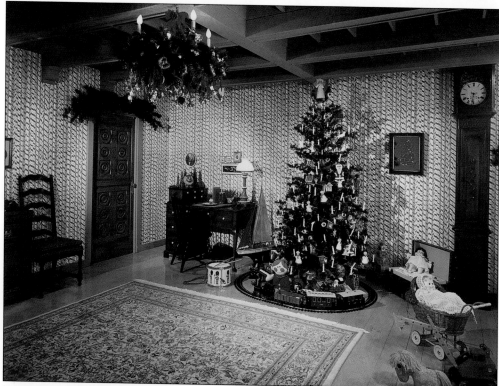

INTERIOR OF COZY CLOUD COTTAGE FROM 1971 WITH CHRISTMAS TREE AND TOYS. (Photo courtesy of Marshall Field's.)

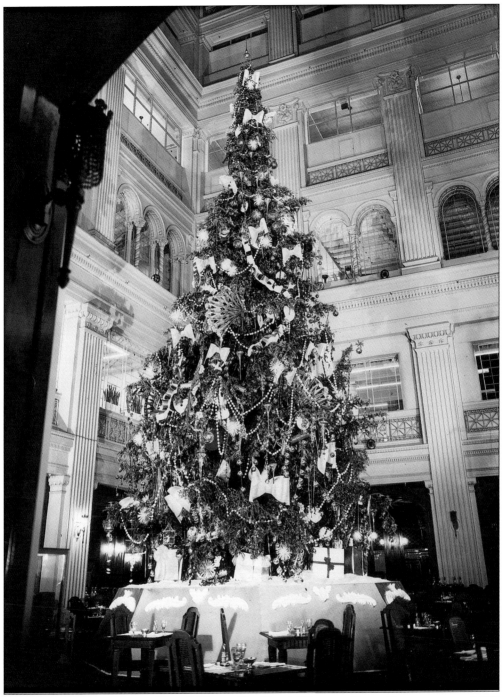

MARSHALL FIELD'S "GREAT TREE" (FRESH FIR TREE) WALNUT ROOM RESTAURANT IN THE 1940s. (Photo courtesy of Marshall Field's.)

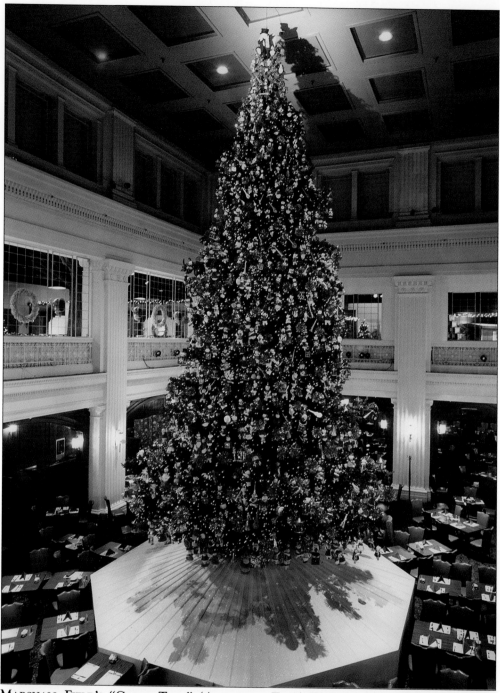

MARSHALL FIELD'S "GREAT TREE" (ARTIFICIAL TREE) WALNUT ROOM RESTAURANT IN THE 1980s WITH UNCLE MISTLETOE ON TOP. (Photo courtesy of Marshall Field's.)

Seven

MANDEL BROTHERS
AND WIEBOLDT'S

The main aisle at Christmas time in Mandel Brothers had a gigantic banner over the archway that read, "Where Christmas Dreams Come True."

Entering the store on the Wabash side, there on the first floor, you could purchase on sale in their extensive clock/timepiece department a Black Forest hand-carved Cuckoo clock for $19.99 or an imported 40 day Moon faced clock for $24.95 in 1955.

The second floor had the camera department, where you could purchase a child's Viewmaster Stereoscope for $2.00 or a packet of 3 reels on Rin-Tin-Tin (the Wonder Dog) for $1.00.

On the third floor you could acquire a domestic console sewing machine, with a lifetime guarantee, made in America for $79.95. But on the sixth floor in the 1950's was Toyland, where each youngster could not only see Santa, but Mandel's own Koko the clown and the Accordion Lady. You could have your picture taken and then explore the wonderful treasure house of toys available. A Gene Autry belt and matching compass set was $2.95 and the famous Monopoly game was sold for $2.00.

In the early years, after visiting Toyland, your Mom and Dad could drop you off on the tenth floor where as a child you could spend many happy hours in 'Happy-Land Shop.' This was a playroom filled with everything from a hobbyhorse to blocks and games all under the watchful eye of a competent attendant.

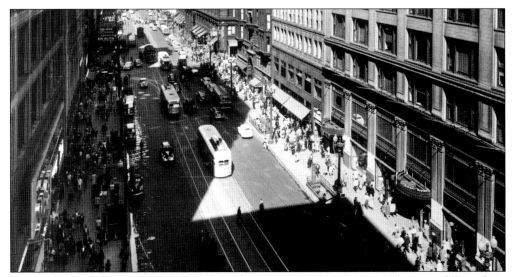

MANDEL BROTHERS BUILDING. State Street, looking north; at lower right is Mandel Brothers Building, proceeding up the street is Charles A. Stevens, the Columbus Memorial Building, Marshall Field's, and the Chicago Theatre. (Photo by Kaufmann & Fabry/courtesy of the University of Illinois at Chicago—The Univ. Library—Department of Special Collections—Chicago Photographic Collection.)

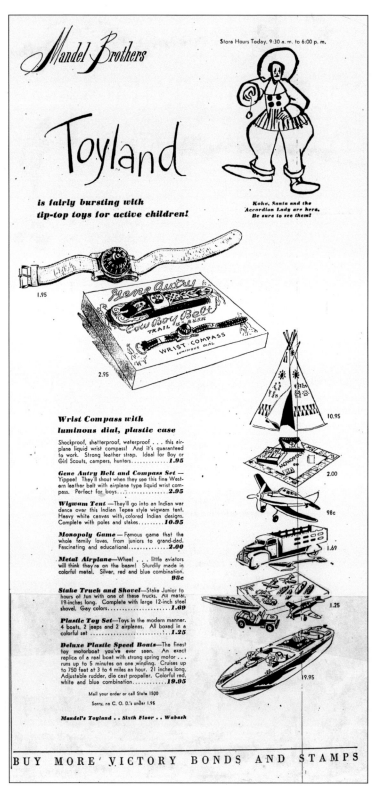

Mandel Brothers

Store Hours Today, 9:30 a.m. to 6:00 p.m.

Toyland

is fairly bursting with tip-top toys for active children!

Koko, Santa and the Accordion Lady are here. Be sure to see them!

1.95

2.95

Wrist Compass with luminous dial, plastic case

Shockproof, shatterproof, waterproof . . . this airplane liquid wrist compass! And it's guaranteed to work. Strong leather strap. Ideal for Boy or Girl Scouts, campers, hunters............**1.95**

Gene Autry Belt and Compass Set — Yippee! They'll shout when they see this fine Western leather belt with airplane type liquid wrist compass. Perfect for boys...............**2.95**

Wigwam Tent —They'll go into an Indian war dance over this Indian Tepee style wigwam tent. Heavy white canvas with colored Indian designs. Complete with poles and stakes........**10.95**

Monopoly Game — Famous game that the whole family loves, from juniors to grand-dad. Fascinating and educational..............**2.00**

Metal Airplane—Wheel . . . little aviators will think they're on the beam! Sturdily made in colorful metal. Silver, red and blue combination. **98c**

Stake Truck and Shovel—Stake Junior to hours of fun with one of these trucks. All metal, 19-inches long. Complete with large 12-inch steel shovel. Gay colors......................**1.69**

Plastic Toy Set—Toys in the modern manner. 4 boats, 2 jeeps and 2 airplanes. All boxed in a colorful set**1.25**

Deluxe Plastic Speed Boats—The finest toy motorboat you've ever seen. An exact replica of a real boat with strong spring motor . . . runs up to 5 minutes on one winding. Cruises up to 750 feet at 3 to 4 miles an hour. 21 inches long. Adjustable rudder, die cast propeller. Colorful red, white and blue combination............**19.95**

Mail your order or call State 1500

Sorry, no C. O. D.'s under 1.95

Mandel's Toyland . . Sixth Floor . . Wabash

10.95

2.00

98c

1.69

1.25

19.95

BUY MORE VICTORY BONDS AND STAMPS

Mandel's was a store for the average shopper, and its Christmas window displays reflected this. The toys and general merchandise in their holiday windows reached the middle class shopper's budget.

In 1960 Mandel's closed their doors. As the *Chicago Tribune* reported in August 1960, the Mandel Brothers approved sale of the store to Wieboldt's in the last meeting of Mandel stockholders. "'It was the largest turnout in many years,' said Col. Leon Mandel, chairman. One stockholder commented: 'All the persons here are attending the burial! Why weren't they here for the birth of the child?'"

A MANDEL BROTHERS FULL PAGE AD FROM 1946: "Toyland" with Koko the Clown, Santa, and the Accordion Lady.

Mandel's merged with the Wieboldt's Department stores in 1961. William A. Wieboldt, founder of Wieboldt's, was born March 8, 1857, near the small town of Cuxhaven, Germany. Prior to his new location on State Street, he had four other stores located in neighborhoods throughout Chicago; Grand and Ashland, Milwaukee and Paulina, Lincoln and Belmont, and Ashland and Monroe.

Wieboldt's was synonymous with the S&H (Speery and Hutchinson Company) Green Stamp people. These stamps were given out, as a give-away promotion, to customers with every purchase they made. The customers would then paste the stamps in the supplied paper books and when they were full would redeem them for various thank you premiums in the redemption centers located in Wieboldt's stores. It was a win win situation and also very good for business. The State Street Wieboldt's had a big redemption center for its customers to select perhaps a small electrical kitchen appliance, a TV, a lamp, a blanket, a foot stool, or even a bicycle, depending upon the number of total books you managed to accumulate.

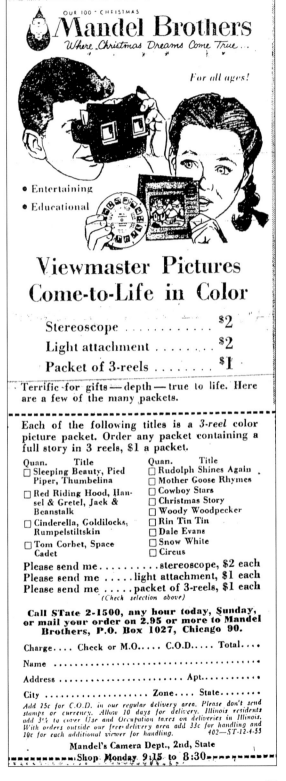

VIEWMASTER AD FROM MANDEL'S.

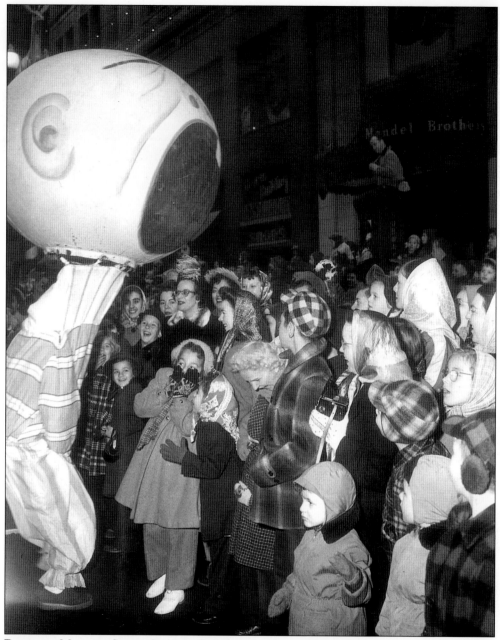

BALLOON MAN ON STATE STREET. Seen here in front of Mandel Brothers is a large balloon figure, amusing the children along the sides of the Christmas Parade on State Street in 1949. (Photo courtesy of The Greater State Street Council.)

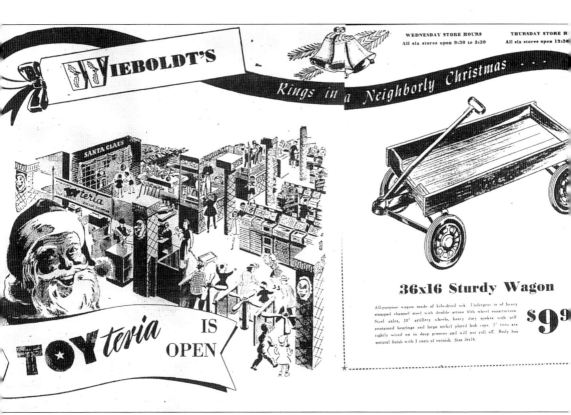

36x16 Sturdy Wagon

$9⁹

All-purpose wagon made of kiln-dried oak. Undergear is of heavy stamped channel steel with double action fifth wheel construction. Steel axles, 10" artillery wheels, heavy duty spokes with self contained bearings and large nickel plated hub caps. 1" tires are tightly wired on in deep grooves and will not roll off. Body has natural finish with 3 coats of varnish. Size 36x16.

WIEBOLDT'S AD OF TOYTERIA FROM DECEMBER 2, 1950. As a convenience to the customers, Wieboldt's had a complete shoe repair shop with a shoe shine service in the bargain basement, as well as direct access to the State Street subway.

If you were on a budget at Christmas, you could watch the newspaper ads and purchase exactly what was needed at a reduced price from the bargain bins located in the basement.

The toy department in all Wieboldt's stores was called "Toyteria;" Santa's modern self-service wonderful wonderland, brimming with toys. As a newspaper ad read: "Self-service Toy shop, where your $1.00 goes farther." In 1950 a streamlined, sturdy hardwood construction, 16 -inch by 36-inch wagon was $9.98.

WIEBOLDT'S MENU—TRAVERTINE ROOM AND WABASH GRILL. On the same floor as the redemption center was Wieboldt's famous Travertine Room and Wabash Grill restaurants. Known for their extensive menus, these two restaurants changed the luncheon specials every day. For example, in 1987, a basic lunch consisted of golden brown French fried Ocean Perch, tartar or cocktail sauce, choice of either mashed or French fried potatoes, roll and butter all for $3.65. Coffee was 45¢ extra, cocktails were $1.55, and fresh strawberry short cake with whipped cream was $1.50.

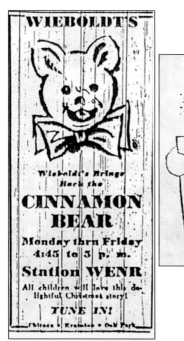

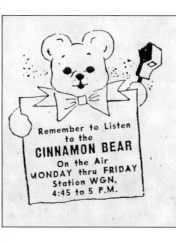

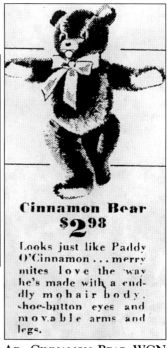

FROM LEFT, CINNAMON BEAR WIEBOLDT'S WENR RADIO AD, CINNAMON BEAR WGN RADIO AD, AND CINNAMON BEAR STUFFED TOY FROM WIEBOLDT'S. One feature Wieboldt's had at Christmas time that no other Chicago store had was the Cinnamon Bear. Long before Wieboldt's reached State Street they were sponsors of a radio show and later a television program called *The Cinnamon Bear*. In the 1940s and 50s the episodes of the show conveyed the story of how the Cinnamon Bear takes his young friends on a trip to "maybe land" in search of the silver star. You could purchase your very own Cinnamon Bear from the Toyteria for $2.98 in the 1950s.

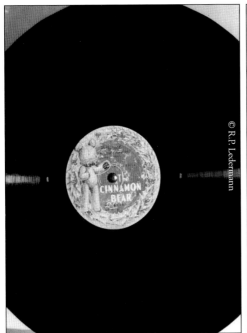

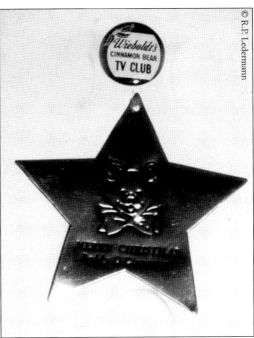

Left: ONE OF 13 TRANSCRIPTION DISKS OF THE ORIGINAL RADIO PROGRAM'S 26 EPISODES. *Right:* THE SILVER STAR PREMIUM GIVEN OUT BY SANTA AT WIEBOLDT'S DEPARTMENT STORES AT CHRISTMAS TIME PROMOTING THE CINNAMON BEAR. The button above was a premium for the TV program also sponsored by Wieboldt's.

It all started the day after Thanksgiving and continued until just before Christmas, Mondays through Fridays. Remembering as the story would unfold those exciting words, as Paddy-O-Cinnamon would say, "And here's the Cinnamon Bear." As a child you would tune in your radio and hear June Marlow introduce *The Cinnamon Bear* sponsored by Wieboldt's Toyteria. She would tell all the children that when they visited the Toyteria at Wieboldt's, they could receive their own free coloring book of the Cinnamon Bear and when they were finished visiting with Santa Claus, he would give each child a genuine silver star of his or her own.

In the 1950s the Cinnamon Bear appeared on TV for a few short seasons as a puppet show from the Chicago WGN studio. The original 1937 radio transcription disks were used for the audio portion of the show.

The Wieboldt's neighborhood Christmas windows in the early 50s featured the lovable brown furry Patty-O-Cinnamon with his bright green bow tie. The few old premiums that were available besides the stuffed toy bear were the give-away silver star, a coloring book, a button with an attached paper tag picturing The Cinnamon Bear, and a few rare 45rpm records which featured the songs from the radio series. The Cinnamon Bear is still popular today.

This radio program was produced in 1937 in Hollywood, California and was syndicated throughout the country. The Cinnamon Bear was created by the late Glen Heisch and Elizabeth Heisch, who also wrote the Cinnamon Bear story for radio. It is very interesting to note that some of the voices used in the radio series became quite famous. Verna Felton played on the *December Bride* and *Lucy* shows; Joseph Kearns became Dennis the Menace's neighbor, Mr. Wilson as well as introduced 'Suspense' on radio; Hanley Stafford became 'Daddy' on radio's *Baby Snooks* and was Dagwood Bumpstead's boss, Mr. Dithers; Frank Nelson became famous on radio and a TV star as the voice of the floorwalker on the *Jack Benny Show*—'YYEESSSS,' and on the *Lucille Ball Show*; and Gale Gordon later played the principal, Mr. Conklin, on the *Our Miss Brooks* TV show and the *Lucille Ball Show*. There were many, many more talented performers that evolved out of the Cinnamon Bear radio programs.

© R.P. Ledermann

WIEBOLDT'S GIFT BOX. William A. Wieboldt retired from active management in 1923 but enjoyed continued success along with his son, Werner, who became president of the store. Wieboldt passed away in 1954 in an Evanston hospital. Many, many years after the founder died, the store sadly closed its doors forever in July 1987. The following is from the *Chicago Tribune*, June 1987. "Wieboldt's Stores, Inc. will close its State Street flagship store at the end of July. Wieboldt's filed for bankruptcy. With the closing, State Street will lose the last budget-priced department store."

Eight

HONORABLE MENTIONS

It wasn't such a long time ago that State Street was filled with prosperous establishments and special buildings, some perhaps a few blocks off State. I would be remiss if I failed to remember them here.

Two other shops at the north end of State Street were The Charles A. Stevens Store and Karoll's Men Shop.

Steven's Women's Apparel Store was founded in 1886 and sold exclusively women's and young women's clothes and accessories. It operated an extensive ladies beauty parlor and on certain days had a continuous fashion show throughout the entire store where models would simply walk about with suggestions on fabrics and accessories. At Christmas time it was one-stop shopping for any gentleman to pick out a special gift for his lady. A favorite perfume or a nightgown or perhaps a cashmere sweater with fur trim. But then, like so many of the other retailers of the time, Steven's filed for bankruptcy with 22.5 million in trade debts in June of 1988. Still another delightful old 'friend' after 102 years of service to Chicagoans left State Street.

CHARLES A. STEVENS, THE STORE FOR WOMEN was located on State Street just before the Washington Street corner. (Photo courtesy of University of Illinois at Chicago—The Univ. Library—Department of Special Collections—Chicago Photographic Collection.)

RELIANCE BUILDING/KAROLL'S MEN'S WEAR SHOP IN 1960. Karoll's was located in the famous Reliance Building, designed in 1890 by Daniel Burnham, who called it a "glass tower." Located at 32 N. State Street at the corner of State and Washington, the 16-story Reliance Building was a sparkling white landmark. It is one of the most intriguing examples of the Chicago school of the modern skyscraper. Karoll's Men Shop, located on the ground floor, featured a selection of suits and topcoats, sportswear (leisurewear), men's furnishings, and accessories. Known as "The Red Hanger Shop" it had the newest trends in fashions for men each year; narrow ties were in one year, the next year it was wide ties. The building in general fell on hard times with decades of neglect, and in 1990 Karoll's closed. The building went through a financial transition, and extensive remodeling and renovation took place. From all the history that the Reliance Building has had there springs forth a charming and trendy new Hotel Burnham in stately grandeur. (Photo by *Chicago Sun-Times* courtesy of The Greater State Street Council.)

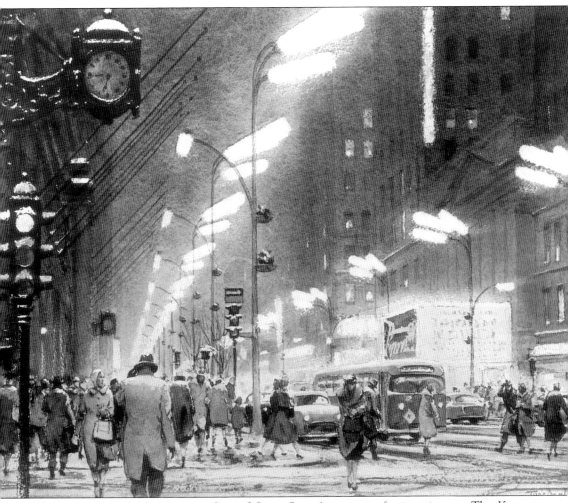

1960s STATE AND RANDOLPH. One of State Street's great confectionaries was The Kranz Candy Store at 126–132 N. State Street. R.W. Bates of Boston and Abner Crossman of Chicago decorated the marble interior of the store. Upon entering the shop, with its Art Nouveau interior surrounded by its walls of bas-relief, its huge marble columns and inlaid tile floors, you could just imagine sitting down to an ice cream treat and know you were sitting in a real ice cream palace. Unfortunately, Kranz's went out of business in 1947.

The 15-story Columbus Memorial Building was built in 1892-93 by William W. Boyington at the southeast corner of State and Washington streets. Boyington was known for his perfection and details, and we fondly remember the massive bronze elevator grill that was part of that old beautiful lobby and the large statue of Columbus in an archway above the entrance. The 10-ton statue sculpted by Sir Moses Ezekiel now stands in Chicago's Arrigo Park. Sadly the Columbus was destroyed in 1959. (Graphic Illustration by Tare Asplund courtesy of The Greater State Street Council.)

HARDING'S COLONIAL RESTAURANT

The Harding's Colonial Restaurant was at 21 S. Wabash. Its motto was, "Just wonderful food at reasonable prices." and it was a wonderful place in the 1950s. As a child, at Christmas and throughout the year, you would be given a 'certificate of merit' if you finished your meal in a well-mannered fashion. This entitled you to a present from their 'Pirate's Treasure Chest.' The age limit was eleven. Girls and boys picked from the child's menu, which had such treats as the Pirate's Pleasure, a broiled beef burger on a toasted buttered bun with sweet pickle relish, ice cream, white or chocolate milk, all for 75¢. Or a Captain Kidd special, which included the meat of the day, creamy, whipped potatoes, vegetable, roll with butter, ice cream or sherbet, white or chocolate milk, all for only 95¢. I can remember the menu stating: 'For good boys and girls, a gift is there, in the old treasure chest beside the stair.' How many generations entered their doors? Now long gone, but not forgotten.

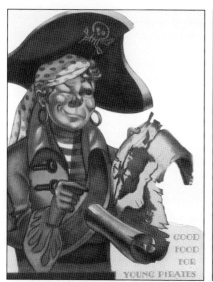

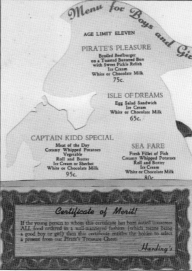

Far Left: **COVER MENU OF HARDING'S COLONIAL RESTAURANT.**

Immediate Right: **OPEN MENU AND "CERTIFICATE OF MERIT."**

INTERIOR. This postcard shows the interior of Harding's Colonial Restaurant at 21 S. Wabash Ave.

KROCH'S AND BRENTANO'S

Just south of Harding's Colonial Restaurant was Kroch's and Brentano's flagship store at 29 S. Wabash Avenue, which was synonymous with books. Known at one time as the 'World's largest bookstore,' Kroch's changed its slogan to 'The full service bookstore' when the national chains took over more of the pie. They trademarked the slogan in 1974—with the emphasis on service, with 100,000 titles to choose from.

At Christmas the Wabash windows were filled with large art books, the latest in biographies, cook books, fiction, books on every imaginable hobby, and of course the latest bestsellers. K & B's windows at the holidays also had gifts, ornate bookends, paperweights, picture frames, and games. It was a feast for a book lover's eye. It was said that if you had your book displayed in a Kroch's window you might have a good chance of it becoming a bestseller. Carl Kroch, known on the street as 'The Baron of Books,' was the son of the founder of the book store, Adolph Kroch, who started selling books in his small business way back in 1907. Kroch would endorse celebrities that came to autograph copies of their books, including Ernest Hemingway, former President and First Lady Jimmy and Rosalyn Carter, Lauren Bacall, Lana Turner, Douglas Fairbanks Jr., James Michener, Margaret Truman Daniel (daughter of the late president), Ivan Albright (the artist), Saul Bellow, and the list goes on. The book business changed and K&B closed in 1995. At the time of its closing, Carl Kroch had sold his shares of the store but was Chairman Emeritus.

© R.P. Ledermann

K&B. This metal Logo of Kroch's and Brentano's Store was on the exterior of the Wabash Avenue building.

THE THEATERS

Want to see some entertainment? That wasn't a problem. Spanning a short 2-block range, Chicago's North State Street had three spectacular movie theatre palaces. The Roosevelt, at 110 N. State, The State and Lake, at 190 N. State, and the last remaining and still active, the original old beauty, The Chicago, at 175 N. State Street. The Chicago opened in 1921 and was designed by C.W. and G.L. Rapp. With its frontage on State Street, The Chicago was the flagship of the B&K chain (A.J. Balaban and Sam Katz). The seating capacity is 3,980 and was designated a Chicago landmark in 1983. The Chicago celebrated its 80th Anniversary in 2001 along with the original mighty Wurlitzer organ built especially for it.

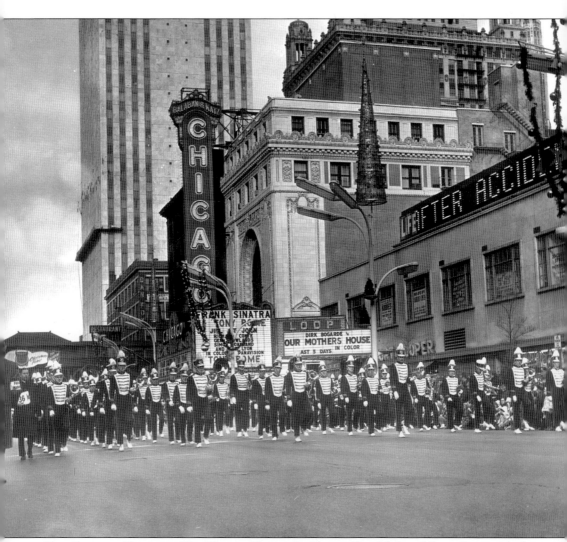

THE CHICAGO THEATER. The Chicago Theatre Building at Randolph and State Street with the Holy Cross High School Marching Band in the 1968 Christmas Parade. (Photo courtesy of The Greater State Street Council.)

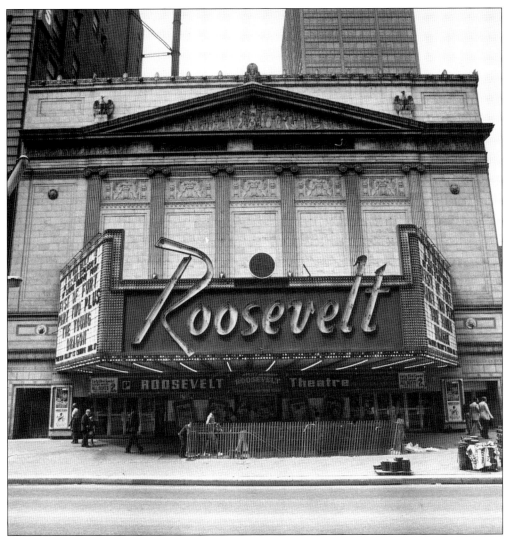

THE ROOSEVELT. The Roosevelt, built in 1921, along with the Chicago and the State and Lake Theatre built in 1917, all had grand lobbies, plush carpeting, marble columns, decorative lighting, mezzanines, balconies, carved ceilings, orchestra pits, and spacious seats. To say these 'lovely ladies' had all the bells and whistles would be an understatement. All three of these theatres had a major part in bringing vaudeville to Chicago. Old timers can remember taking in a vaudeville act (stage show), seeing a newsreel and seeing two feature films in the 30s and 40s all for only 50¢ or less.

Remember date night? Saturdays with your favorite date to a fabulous downtown theatre that took you far away into a place like nothing you could have imagined. Along with the State and Lake, The Roosevelt and The Chicago, perhaps you remember others. (Photo courtesy of The Greater State Street Council.)

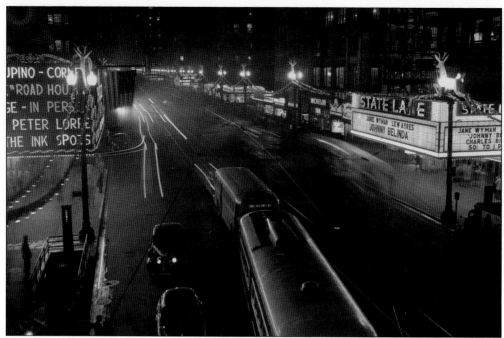

STATE AND LAKE. The State and Lake building itself was completely remodeled for the new WLS/ABC TV station in 1984. The Roosevelt was demolished in 1979. (*The Chicago Sun-Times*/courtesy The Greater State Street Council—1948 photo.)

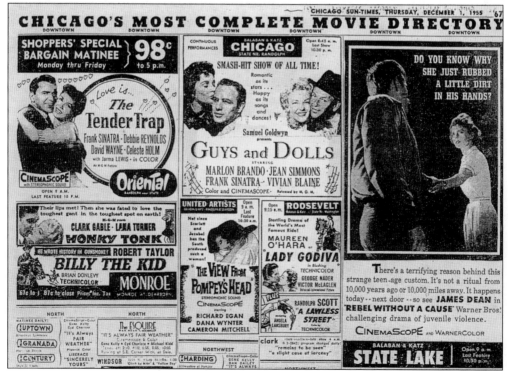

MOVIE DIRECTORY FROM 1955 WITH VARIOUS DOWNTOWN LOOP THEATRES LISTED.

THE BUTLER BUILDING

The Butler Building at 162 N. State Street, a 16-story office building, was built in 1924 by C.A. Eckstorm. To the right was the State and Lake Theatre. Pop around a corner and you'd find others, including The McVickers at 25 W. Madison, The Monroe at 57 W. Monroe, The Oriental (now re-opened) at 20 W. Randolph, The United Artists at 45 W. Randolph, the Michael Todd which is now the new Goodman Theatre, and the Woods at 54 W. Randolph. These were only a few I use to frequent; the Loop was dotted with numerous 'lovely ladies.' Sad and bittersweet are the memories of these palaces, most of them gone forever, except in our mind's remembrances. (Photo courtesy of University of Illinois at Chicago—The Univ. Library—Department of Special Collections—Chicago Photographic Collection.)

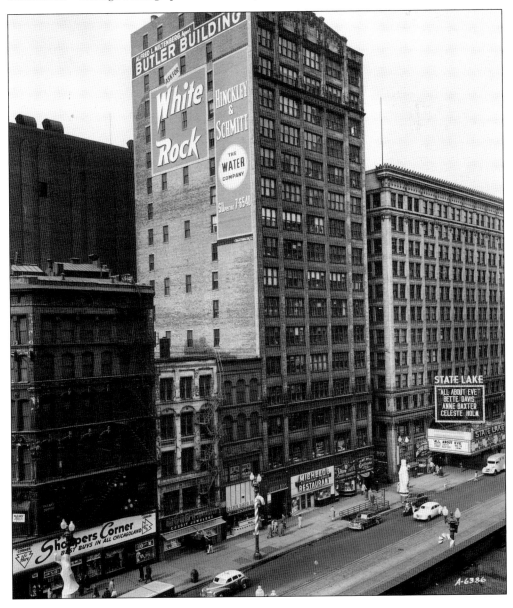

FRITZEL'S

If, after leaving one of the theaters you wanted a good meal, you could have tried one of Chicago's best, Fritzel's Restaurant at 201 N. State Street, at the northeast corner of State and Lake. It welcomed celebrities like they were family. Mickey Mantle, Yogi Berra, Joe DiMaggio, Marilyn Monroe, Tony Bennett, and Phyllis Diller all frequented Fritzel's, and could have been 'news' in the next day papers. Newspaper columnists like Irv Kupcinet got many leads to great stories there. Fritzel's started on State Street in 1947 and continued on State Street until 1968 when then owner Joe Jacobson sold the restaurant to Interstate United Corporation, a food service firm, which ran the business until 1972 when the doors closed.

Esquire magazine, in its 'Dining In/Out' column of November 1965, said, "Fritzel's is not merely a fine restaurant where celebrities abound: it is a restaurant where the owner is a celebrity." Fritzel's was also known for its famous piano bar where many a Chicago executive or politician had the notorious three martini lunch. At Christmas time couldn't you just imagine all the fun...?

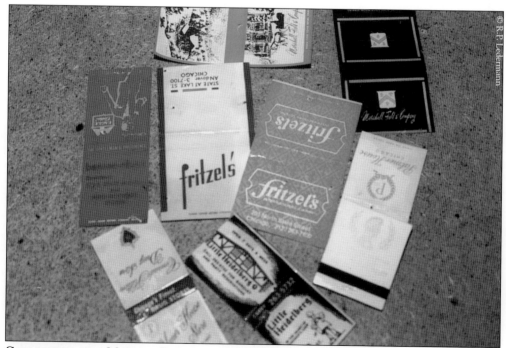

COLLECTION OF MATCH COVERS WITH FRITZEL'S AND VARIOUS BUSINESSES ON STATE STREET.

Nine

MARSHALL FIELD'S

Finally we arrive at the crown jewel of State Street, Marshall Field's, located on one entire square block bounded by Washington, State, Randolph and Wabash. As people scurry up and down the snow-laden streets of the loop, we find ourselves anticipating the coming holiday season. Look around and notice about you all the wonders of Christmas. Even the streetlights have an appearance all their own. See the happy smiling faces of the people passing carrying brightly wrapped gift packages. Everyone seems to be getting ready, each in his own way.

Field's current store, as we see it today, was opened to the public on September 30, 1907. If you can imagine, in that first week some 300,000 visitors entered through its welcoming doorways. It's hard to comprehend that Marshall Field (The Merchant Prince), who founded this store, had arrived in Chicago from Massachusetts at the young age of 22 way back in 1856. His incredible idea to start an empire selling merchandise had its meager beginnings on the muddy streets of Chicago.

LATE 30S OR EARLY 1940S MARSHALL FIELD'S CORNER WINDOW AT STATE AND WASHINGTON. Patiently, every year, Chicagoans await the wonders to be seen in the magnificent Field's windows. (Photo courtesy of Marshall Field's.)

NIGHT VIEW OF MARSHAL FIELD'S AT THE CORNER OF WASHINGTON AND STATE STREET. (Photo courtesy of Marshall Field's.)

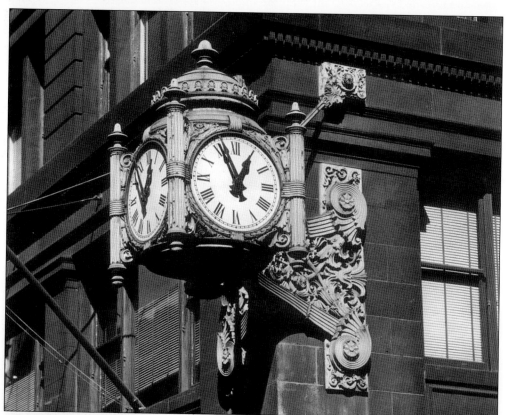

FIELD'S CLOCK. As we look above us, we see the massive Field's clock. The first clock was installed on November 26, 1897, at the corner of State and Washington. Ten years later, in 1907, a second identical clock was installed on State and Randolph. Both were designed by Perice Anderson of Anderson, Probst and White, architects for the State Street store. Each clock frame that supports the clock weight is $7^3/_4$ tons of cast bronze. The clock's minute hand is 27 inches long and the hour hand is $20^1/_2$ inches long. The face is 46 inches across, is made of glass, and is illuminated by lights within the clock, which also keeps the clockworks warm and dry. How many times have you said to a friend, "I'll meet you under the clock at Field's?" On November 3, 1945, the *Saturday Evening Post*'s cover featured Norman Rockwell's painting of a repairman setting the landmark clock by his own pocket watch. (Photo courtesy of Marshall Field's.)

In 1944 Field's brought the charming, classic poem, "A visit from Saint Nicholas," by Clement C. Moore, into the giant windows. These were well received and repeated in 1945. The 1945 windows follow. . . .

*'Twas the night before Christmas
when all through the house
Not a creature was stirring,
not even a mouse.*

*The stockings were hung
by the chimney with care
In hopes that St. Nicholas
soon would be there.*

*The children were nestled
all snug in their beds,
While visions of sugar-plums
danced in their heads.*

(Both photos courtesy of Marshall Field's.)

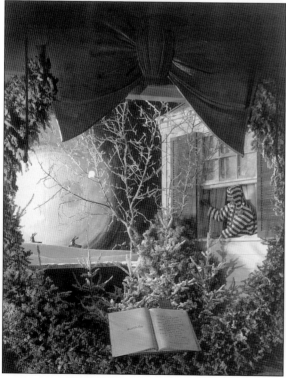

And mamma in her kerchief,
and I in my cap,
Had just settled our brains
for a long winter's nap.

When out on the lawn
there arose such a clatter,
I sprang from the bed
to see what was the matter.

Away to the window
I flew like a flash
Tore open the shutters
and threw up the sash.

The moon on the breast
of the new fallen snow
Gave a lustre of mid-day
to objects below.

(Both photos courtesy of
Marshall Field's.)

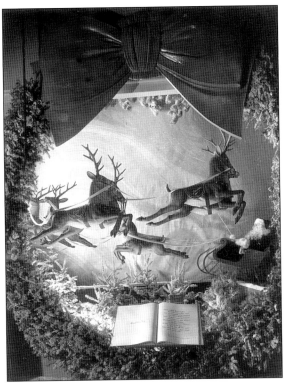

When, what to my wondering
eyes should appear,
But a miniature sleigh,
and eight tiny reindeer.

With a little old driver,
so lively and quick,
I knew in a moment
it must be St. Nick.

More rapid than eagles
his coursers they came,
And he whistled, and shouted,
and called them by name;

'Now, Dasher! Now, Dancer!
Now, Prancer and Vixen!
On, Comet! On, Cupid!
On, Donder and Blitzen!'

'To the top of the porch!
To the top of the wall!
Now dash away! Dash away!
Dash away all!'

As dry leaves that before
the wild hurricane fly,
When they meet with an obstacle,
mount to the sky,

So up to the house-top
the coursers they flew,
With the sleigh full of toys,
and St. Nicholas too.

And then, in a twinkling,
I heard on the roof
The prancing and pawing
of each little hoof.

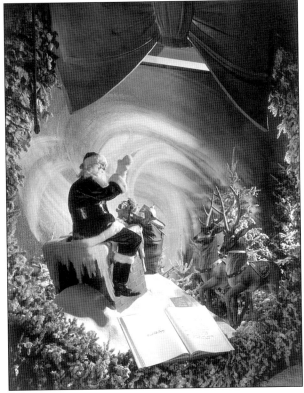

(Both photos courtesy of
Marshall Field's.)

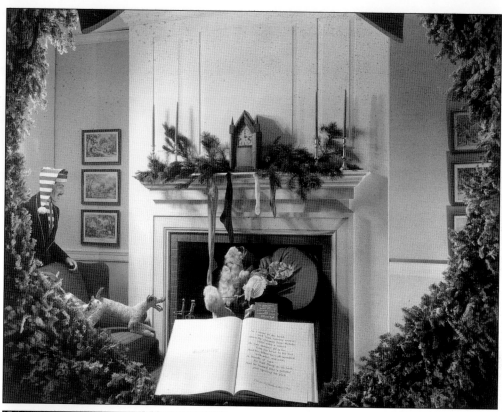

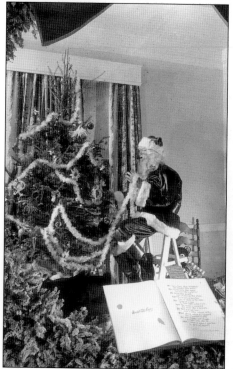

As I drew in my head, and was turning around,
Down the chimney St. Nicholas came with a bound.
He was dressed all in fur, from his head to his foot,
And his clothes were all tarnished with ashes and soot
A bundle of toys he had flung on his back,
And he looked like a peddler just opening his pack,
His eyes - how they twinkled! His dimples how merry,
His cheeks were like roses, his nose like a cherry!

His droll little mouth was drawn up like a bow,
And the beard of his chin was as white as the snow:
The stump of a pipe he held tight in his teeth,
And the smoke it encircled his head like a wreath.
He had a broad face and a little round belly,
That shook, when he laughed, like a bowlful of jelly
He was chubby and plump, a right jolly old elf,
And I laughed when I saw him, in spite of myself.

(Both photos courtesy of Marshall Field's.)

A wink of his eye
and a twist of his head,
Soon gave me to know
I had nothing to dread.

He spoke not a word,
but went straight to his work,
And filled all the stockings;
Then turned with a jerk,

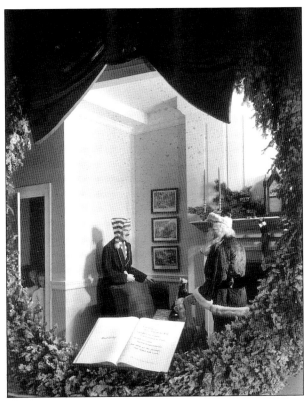

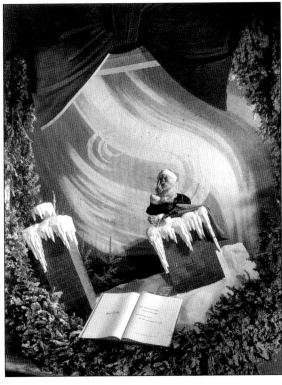

And laying his finger
aside of his nose,
And giving a nod,
up the chimney he rose;"

(Both photos courtesy of
Marshall Field's.)

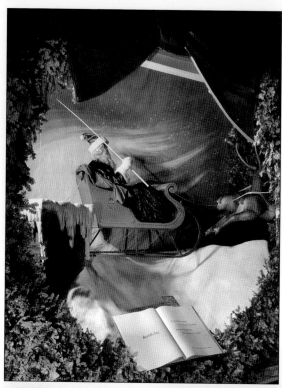

He sprang to his sleigh,
to his team gave a whistle,
And away they all flew
like the down of a thistle.

But I heard him exclaim,
ere he drove out of sight,
'Happy Christmas to all,
and to all a good-night.'

What surprises will there be this year?
In 1946? Will there be something new
added, that will be Field's alone?

(Both photos courtesy of
Marshall Field's.)

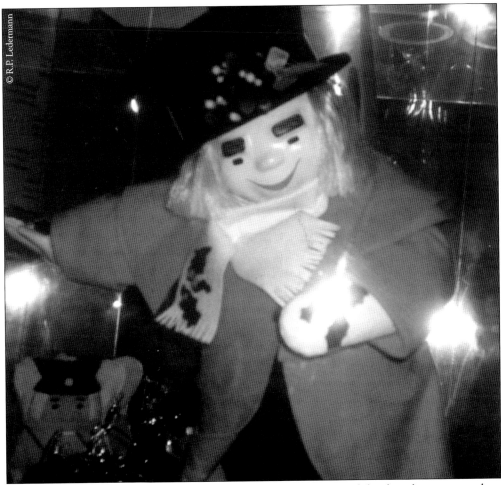

UNCLE MISTLETOE. This 1950s Uncle Mistletoe figure was one of the five that were used on the top of Field's great trees. Now there is a new little friend to Santa Claus, he is a chum, a helper who will know Santa's ways, to aid him and to advise and report back to Santa of all the good and kind boys and girls everywhere. His name is Uncle Mistletoe. He appears for the first time in the Field's Christmas story poem windows, entitled "A Christmas Dream," by Helen McKenna, a copywriter for Field's.

His clothes are suited for the holiday season. He is dressed in a bright red coachman's coat and a tall black top hat trimmed with mistletoe greens. He has gauzy white wings and a long white silk scarf similar to those worn by early aviators, for after all, he is somewhat of a flyer himself, checking about in the sky, looking for all children who remember to take time to be kind. His face has bushy black eyebrows and a big smile from ear to ear.

At first glance, Uncle Mistletoe might take you back to a character out of a page from a Charles Dickens novel.

Passing each Marshall Field's Christmas window in 1946, the story of "A Christmas Dream" unfolds. This is the story of a little boy named Jim-Jam and his sister, Joann. Their house is, as with most houses at the holiday time, filled with Christmas expectations, for it is Christmas Eve. Their parents send them to bed early. In their dreams Uncle Mistletoe visits them, through their bedroom window, on his magical flying carpet and chooses the two of them to go on an excursion ride up to visit Santa Claus at the North Pole. Santa greets them warmly and shows them the elves making toys for the children all over the world. The windows are as follows. . . .

91

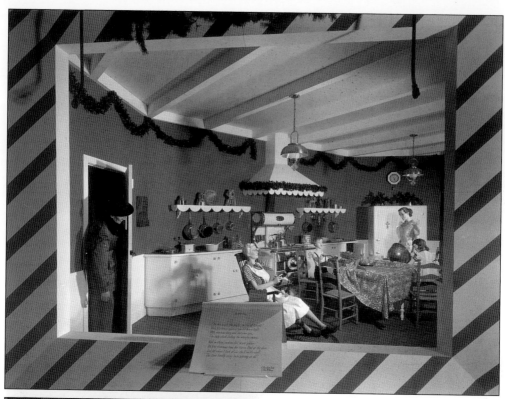

Oh, the thingle, the jingle, the fun of tonight!
With Christmas upon us, the kitchen a-light
With everyone busy and everyone gay,
The busy clock ticking the minutes away:
With mistletoe, cookies, and secrets galore—
It's tree trimming time for there's Dad at the door,
And yet when I look at our clock on the wall,
The time hardly seems to be moving at all!
'I wish we could stay up like ladies and men!
Oh, when will it ever be morning again?'
The night wind blows sweetly, a new star is born,
And hark! Did you hear it? That faraway horn?

They hadn't slept long when an odd little guy
A riding a carpet, flew in and said, 'Hi!
My names Uncle Mistletoe!
Just take my hand,
We're going on a journey
to Santa Claus Land!'

(Both photos and text courtesy of
Marshall Field's.)

92

'Well—jeepers!' cried Jim-Jam;
and 'Joy!' cried Jo-Ann,
'But why did you choose us,
you funny old man?'
Their visitor winked and said,
'Step lightly—mind!
I only choose those
who take time to be kind!'

Oh, marvelous carpet,
so fleet and so light!
They laughed with the moon
as they sped through the night;
And old Uncle Mistletoe,
feeling quite gay,
Did loops and did spirals
most all of the way.

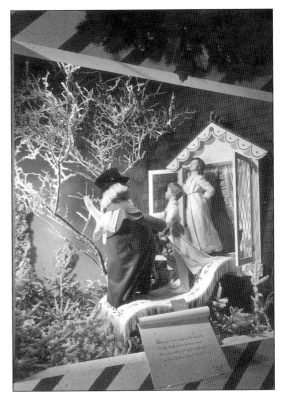

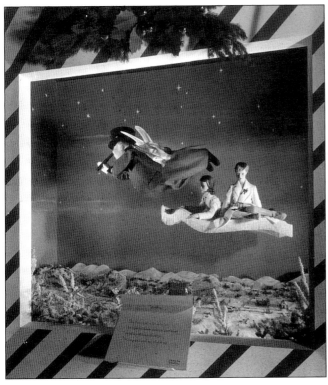

(Both photos and text
courtesy of Marshall Field's.)

93

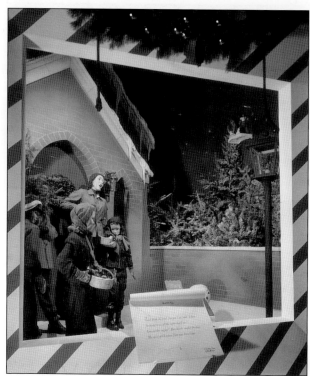

'Look down Jo,' cried Jim-Jam,
'I am,' said Jo-Ann,
'I'm trying to see
all the sights that I can!'
Look, carolers singing,
Their hearts caught the glow,
The spirit of Christmas
from way down below.

Far northward they see it, the beckoning
beam
of Santa Claus' signboard.
As if in a dream,
They land, park the carpet—
and Prancer with pride,
Takes time off from primping
to give them a ride!

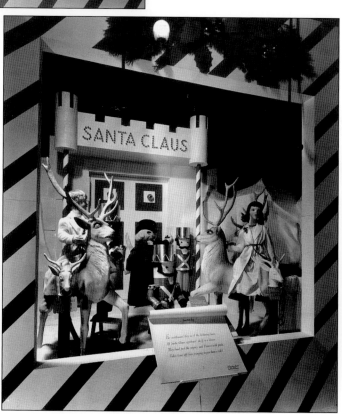

(Both photos and
text courtesy of
Marshall Field's.)

Inside what a humming!
What glitter and gleam!
With toys being made in an
unending stream.
Jo's eyes danced with fun though the
glare made her blink—
'Here's toys for the whole world—
and more I should think!'

They walked through the castle more
wonders to see,
They watched workers,
garlanding each shining tree:
'Let's wish hard,' said Jim, 'for those
ornaments bright
To slide down through everyone's
dreams for tonight!'

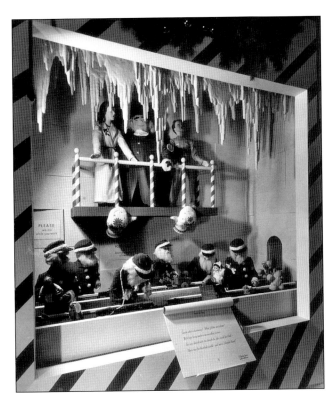

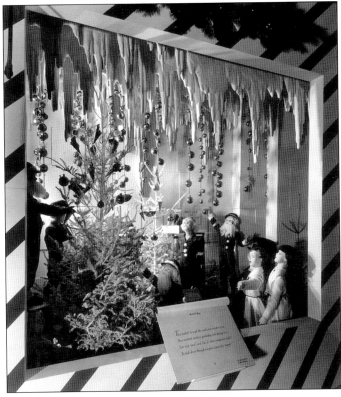

(Both photos and
text courtesy of
Marshall Field's.)

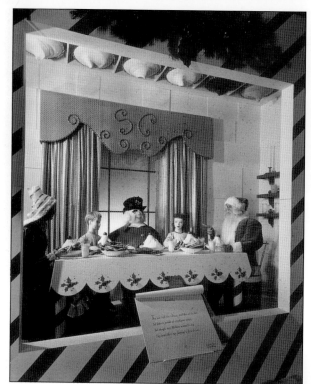

They met both the Clauses,
and then at the last,
Sat down to partake
of a toothsome repast.
And though even Mistletoe
wanted to stay,
They heard their rug flapping
to be on its way.

'So now if you've finished
your cake and ice cream,
Accept these small tokens
of Santa's esteem!'
They thanked him politely,
took leave of their host—
And found each had
just what he'd wanted the most!

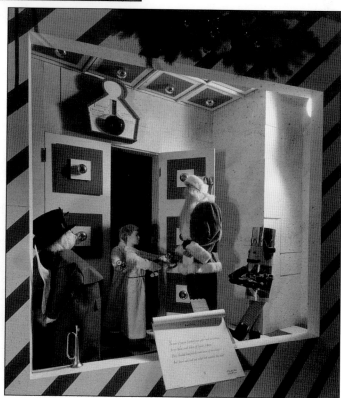

(Both photos and
text courtesy of
Marshall Field's.)

*"They're home in a flash; Uncle Mistletoe's
gone,
'I love him I do!' Jo-Ann smothered a yawn,
And Jim murmured drowsily, 'I'd just like to
know
Where Unc got his carpet and what makes it
go!'"
"Oh, whooper-doo super-doo fun of today!
Stop cuckoo from ticking the minutes away!
It's fun, when you're dreaming the night skies
to roam
But there's nothing, just nothing, like
Christmas at home!"
So thanks, Uncle Mistletoe, you and your
rug—
He'd waved them goodbye
With a wink and a shrug
But his horn and his hearty voice float down
the wynd.
"Merry Christmas. . .remember. . .Take time
to be kind!"*

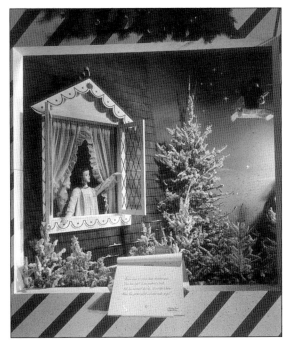

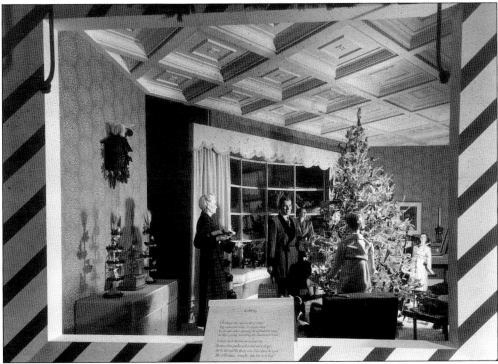

In the very last set of windows at Washington and State Street, you see the children awake and in the living room stands their own bright and shiny Christmas tree. All their Christmas dreams come true with presents underneath the tree and Mom and Dad are there too. These were truly a magnificent group of windows that were enjoyed by young and old alike. (Both photos and text courtesy of Marshall Field's.)

Of foremost importance to Marshall Field's is the creation each year of the famous Field's windows.

Generally, early in January a theme is created and formed, colors and materials are thought out, and many times a scale model of each window is presented for the executive's final approval or changes. After they give their approval, the window display staff get the task of replicating these models to life size proportions in the windows. From Labor Day on, the window staff will work full time to complete each of the windows. There were 13 original windows with months of planning and work going into each one before it is unveiled to the public in the weeks before Thanksgiving. The finest materials and meticulous workmanship go into these windows, including such items as real pewter pieces or an antique miniature piece of furniture.

How Christmas comes to Field's in a 1972 Window. (Photo courtesy of Marshall Field's.)

Depicting Trimming the Great Tree in the Walnut Room, in a 1972 Window. (Photo courtesy of Marshall Field's.)

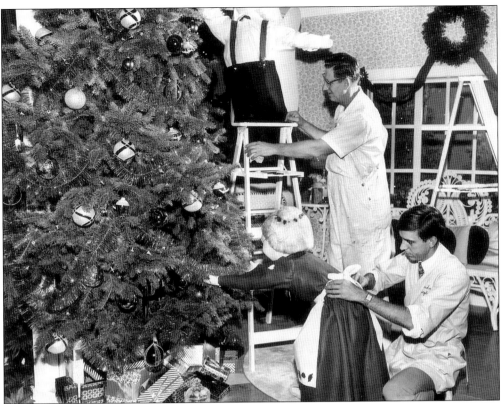

WINDOW TRIMMERS PREPARING A 1965 CHRISTMAS WINDOW. The man standing by the ladder is Milan Budza. (Photo courtesy of Marshall Field's.)

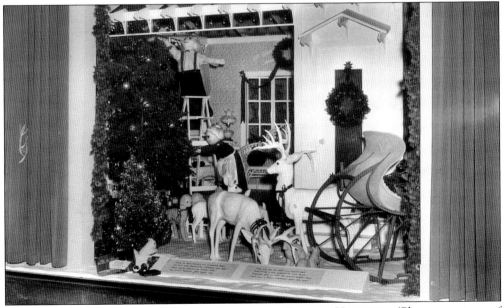

THE COMPLETED 1965 WINDOW, READY FOR PUBLIC VIEWING. (Photo courtesy of Marshall Field's.)

THE GRANITE COLUMNS. Before entering the store, we stop to admire the large granite columns that effectively make a mark by just being there. Their imposing beauty echoes the gigantic vista of the Main entrance on State Street. These columns are believed to be the largest monoliths in the nation—They are 48 feet 9 inches high and 3 feet 6 inches in diameter. (Photo courtesy of Marshall Field's.)

A 1971 NIGHT VIEW OF MARSHALL FIELD'S EXTERIOR WITH DANGLING SNOWFLAKES. The Chicago Theatre is in the background. (Photo courtesy of Marshall Field's.)

Entering the revolving doors at Field's, we are transported into a place of wonderment: the main aisles. Over our heads, silver, white, and gold snowflakes are cascading down, dangling as if from the incredible mosaic of the Tiffany dome. The dome has about 1.6 million pieces of glass. It is said to be the finest example of its kind. It took 50 artisans a year and a half to install. At the time of the dome's commissioning, the then president of Marshall Field's, Mr. John Shedd, founder of Chicago's famous Shedd Aquarium, helped Louis Comfort Tiffany with every phase of the dome—from planning the curving of the multi-colored Favrile glass structure through to its completion, when it became the highlight of the vast 385-foot aisle. The dome was unveiled to the public on September 30, 1907, the first day of the formal opening of the completed retail store.

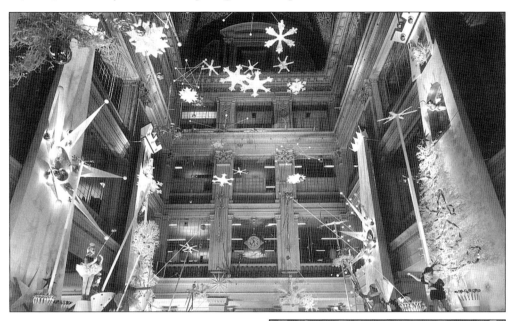

SNOWFLAKES CASCADING DOWN FROM THE MAIN AISLE WITH TIFFANY DOME ABOVE. All decorations in the scenes were created in the carpenter shop and all the ornaments were hand made in the 13th floor studio. This photo is from 1953. (Photo courtesy of Marshall Field's.)

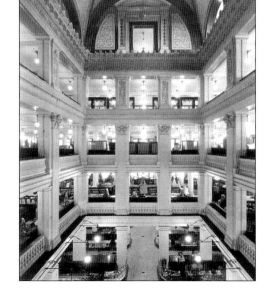

THE "WELL" WITH THE FAMOUS TIFFANY DOME ABOVE BEFORE METAL LATTICE WORK WAS INSTALLED IN THE SOUTH ATRIUM. (See also color insert.) (Photo courtesy of Marshall Field's.)

PREPARING THE 1949 MAIN AISLE, GARLAND IS BRACED UP OVER ARCHWAYS. (Photo courtesy of Marshall Field's.)

LARGE WREATH AND SNOWFLAKE ARE HOISTED OVER THE MAIN AISLE, 1949. (Photo courtesy of Marshall Field's.)

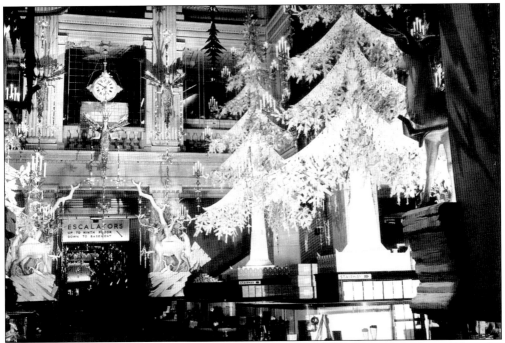

THE 1941 MAIN AISLE TRIMMED WITH WHITE FROSTED FORESTRY AND REINDEER. Note the winter snow queens over the archway. (Photo courtesy of Marshall Field's.)

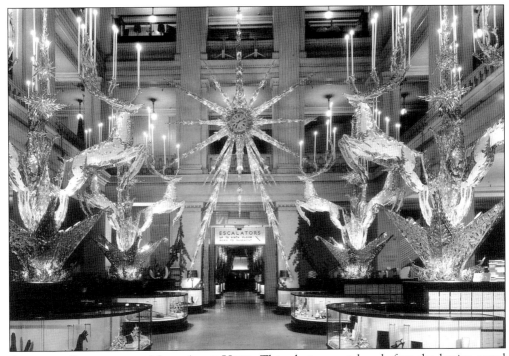

ANOTHER SPECTACULAR MAIN AISLE VIEW. This photo was taken before the lattice metal work was installed. While walking through the main aisle one had the feeling the reindeer were made of ice. (Photo courtesy of Marshall Field's.)

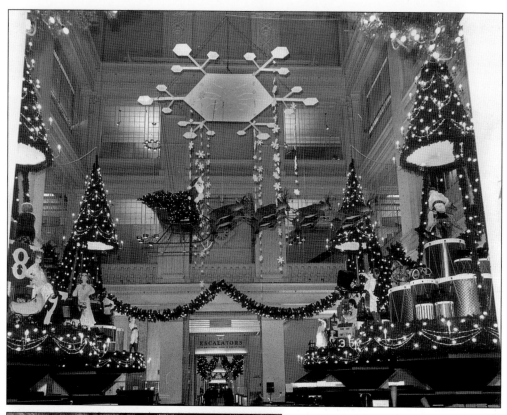

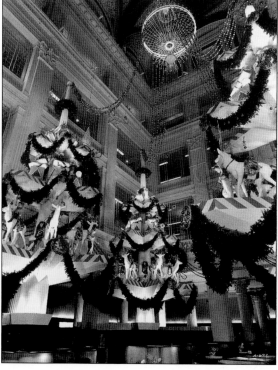

THE MAIN AISLE WITH SANTA AND REINDEER FLYING OVER FIELD'S ARCHWAY. (Photo courtesy of Marshall Field's.)

THE 1948 MAIN AISLE WITH HAND-STRUNG GLASS ORNAMENT GARLAND CASCADING FROM THE TOP OF A CHANDELIER-TYPE ORNAMENT BELOW THE TIFFANY DOME. (Photo courtesy of Marshall Field's.)

THE 1951 FRESH TREE IN THE WALNUT ROOM WITH HAND-MADE ORNAMENTS AND UNCLE MISTLETOE AT THE TOP AS WELL AS UNCLE MISTLETOE AND AUNT HOLLY SURROUNDING THE BASE. (Photo courtesy of Marshall Field's.)

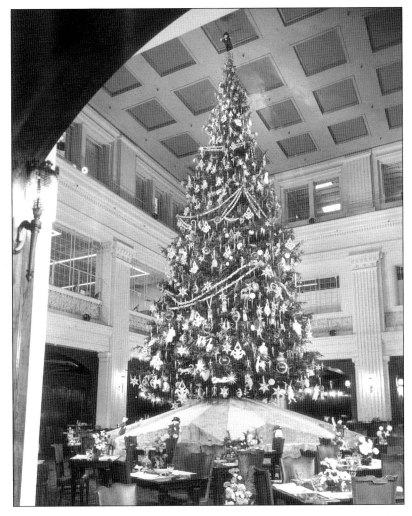

There is a feeling of anticipation as we journey up to the Walnut Room restaurant. We could either use the gleaming stainless steel escalators, which were first installed in 1933 to commemorate Chicago's Century of Progress Exposition, or cruise up the elevators to the 7th floor where more delightful things await us. We decide to take the elevators, which have an interesting story to tell on their own. One of the Field's elevator operators was Dorothy Lamour, who wasn't an actress at the time, but gained her entry in to show business by singing at an audition in Chicago. She was in such a hurry to get to the audition on time that she still was wearing her elevator uniform.

The elevator door opens wide and we step into the elegant setting of the Walnut Room restaurant. Surrounding us is Circassian walnut paneling and crystal chandelier sconces that enhance the beauty of the natural wood. There are square oak tables covered with white linen cloths, silver plate service sets of utensils, silver plated condiment sets, cold beakers of fresh water, and a vase of fresh flowers.

In the center of this beautiful setting stands the great tree. This tradition began in 1907. The tree itself stands an enormous 45 feet high from base to top. During the days when Field's had a fresh Christmas tree, the procedure would be that in late autumn team members would head out for either Lake Superior County in Minnesota or the Upper Peninsula of Michigan to select the tree with the aid of a professional timber expert.

UNCLE MISTLETOE IN SEARCH OF THE "GREAT TREE." A symmetrical balsam fir 70 feet tall is required. Carefully the top 45 feet are looped and lowered by block and tackle to prevent any damage to the branches, which are bound tightly to the trunk. A bulldozer breaks a path through the forest and the tree is hauled by sled to the railroad where a flatbed car is waiting to take it to Chicago. While the last customers leave the store on a Saturday, the workers get into high action to receive the tree. Chicago streets are blocked off to permit a huge trailer truck to carry the tree to the store. (Photo courtesy of Marshall Field's.)

SELECTION OF A FRESH TREE IS CUT FOR 1951 MARSHAL FIELD'S GREAT TREE. (Photo courtesy of Marshall Field's.)

BRINGING THE FRESH TREE INTO FIELD'S THROUGH THE RANDOLPH STREET DOORS IN 1943. The revolving doors at the Randolph and State entrance are removed. The tree with its base packed in peat moss slides neatly through the opening and is hoisted 7 floors through the atrium, then moved to the Walnut Room where the former fish pond is drained and block and tackle is ready to set it in place.(Photo courtesy of Marshall Field's.)

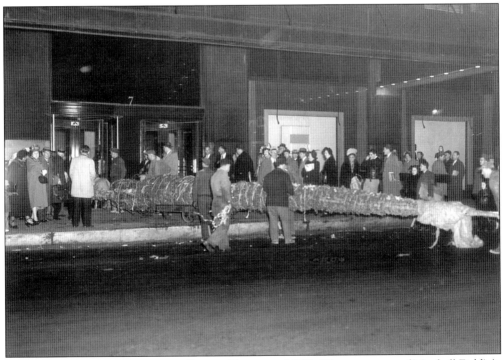

GOING THROUGH THE RANDOLPH STREET DOORS IN 1955. (Photo courtesy of Marshall Field's.)

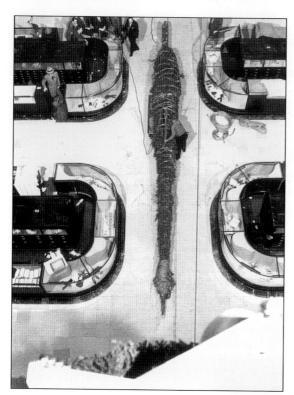

MOVING THE TREE THROUGH THE MAIN AISLE OF THE STORE. (Photo courtesy of Marshall Field's.)

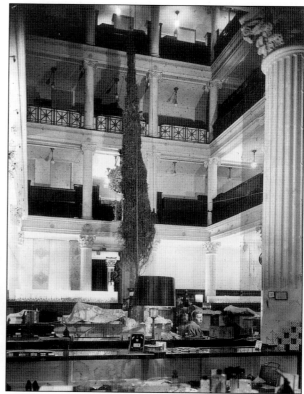

HOISTING THE FRESH TREE UP THROUGH THE ATRIUM. (Photo courtesy of Marshall Field's.)

HOISTING ANOTHER FRESH TREE TO THE 7TH FLOOR WALNUT ROOM, 1955. Notice the metal lattice work above the main aisle and the stream line stainless steel escalators. (Photo courtesy of Marshall Field's.)

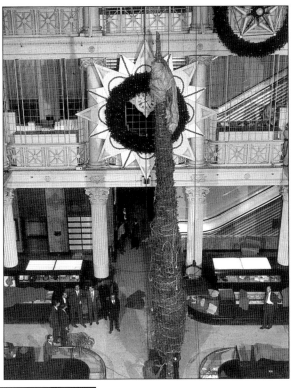

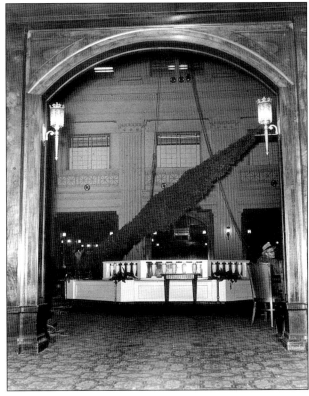

TREE IS HOISTED AND FITTED INTO PLACE IN THE CENTER OF THE WALNUT ROOM WITH BLOCK AND TACKLE. (Photo courtesy of Marshall Field's.)

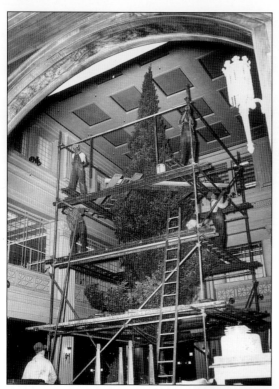

ERECTING SCAFFOLDING AROUND FRESH TREE FOR TRIMMING. (Photo courtesy of Marshall Field's.)

PLACING ORNAMENTS ON THE TREE. The ornaments were handmade on the 13th floor. (Photo courtesy of Marshall Field's.)

The fresh evergreen trees that were first introduced created somewhat of a problem. A Chicago fireman would always keep a visual watch guarding against a fire. Just think of the destruction, let alone the panic and confusion a disaster such as this might cause. Because of this danger, a change to an artificial tree was made to ease the minds of all concerned. In the early 1960s Field's negotiated a commission for the creation of such a tree with Charles Cohen and his partner Gus Mittlemark of the Colonial Decorative Display Company of New York. The original artificial tree they made still stands today. "Some of the larger branches are as long as 15 feet and can weigh as much as 50 pounds each," Mr. Cohen told me in 1980, on one of his trips to Field's to personally supervise the tree's set-up. He was a fine man who took personal pride in his work.

In years past you could look up to the very top and would find that Uncle Mistletoe had flown to his favorite spot, at the top of the tree, where he observed all that was happening below.

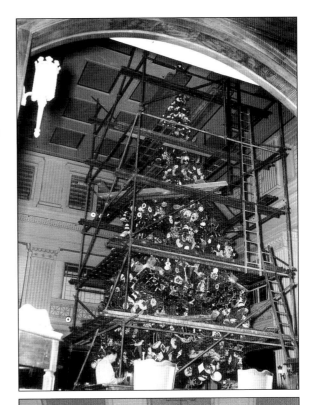

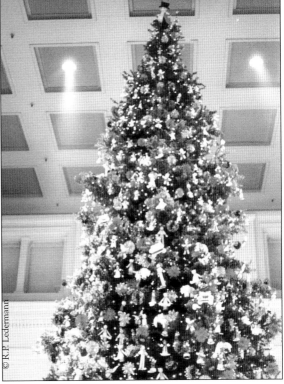

Top: **ALMOST COMPLETED FRESH TREE WITH SCAFFOLDING STILL UP, IN 1955.** (Photo courtesy of Marshall Field's.)

Bottom: **ARTIFICIAL TREE WITH UNCLE MISTLETOE ON TOP.**

© R.P. Ledermann

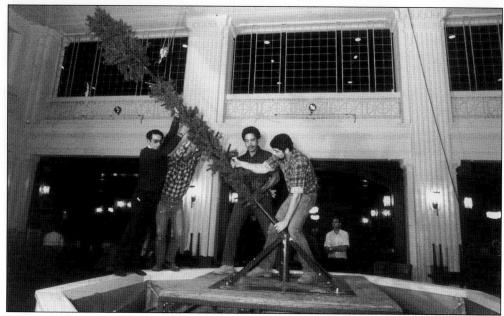

TRIMMERS. Before the artificial tree is trimmed, scaffolding is built around it enabling the tree trimmers to decorate it. A basic theme is chosen each year. The trimmers climb high up on the scaffolding and guarantee that each of the ornaments is secured and perfectly placed on the tree. These ornaments were usually all handmade throughout the year by Field's employees. Using a master chart designed by the Interior Display department, ornaments of 3 various sizes would be hung on the tree accordingly; small for the top branches, medium sized for the middle section, and larger ones at the bottom. (Photo courtesy of Marshall Field's.)

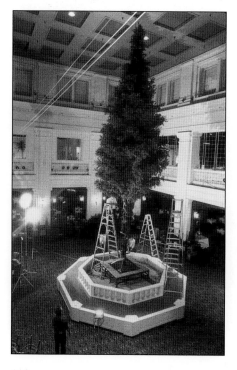

TOP PORTION OF ARTIFICIAL TREE WITH HYDRAULIC LIFT UP TO CEILING USING BLOCK AND TACKLE. (Photo courtesy of Marshall Field's.)

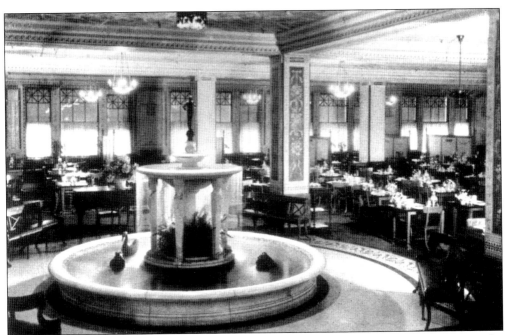

THE NARCISSUS ROOM. The Narcissus Room in 1941 was another fine dining room on the seventh floor, which opened in 1914 and closed in 1987. It was first converted into an employee lunchroom and later a special events center. (Photo courtesy of Marshall Field's.)

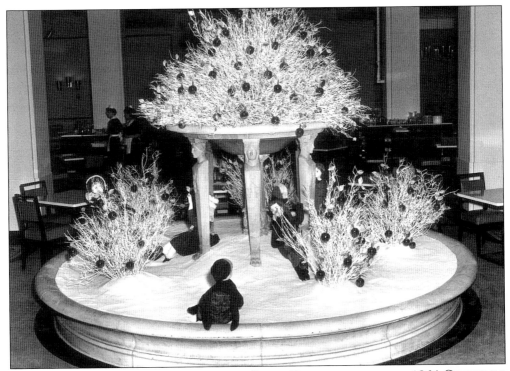

THE WATER FOUNTAIN IN THE NARCISSUS ROOM DECORATED FOR THE 1964 CHRISTMAS SEASON. (Photo courtesy of Marshall Field's.)

SKETCHES. (Courtesy of Marshall Field's/Addis Osborne Sketch.) One might ask, "How did Uncle Mistletoe come to be?" Not in the cold snowy winter but on an extremely warm spring evening in 1946, in the Williams Bay, Wisconsin, summer home of Johanna Osborne, a Marshall Field's employee. Her boss John Moss, Director of Design, had approached her a few weeks earlier with a new project. He had told her of all the past windows and how they now wanted something completely different that would be Field's alone. Now at her summer home, Johanna's thoughts turned to her favorite uncle, Uncle Ola, who lived in Oslo, Norway. Her fondness for Charles Dickens and his characters, and another favorite of hers, *The Arabian Nights*, all combined into a single thought. This was going to be her idea behind Uncle Mistletoe. She remembered her uncle as being somewhat stout, with white hair, a very jolly person, and one who loved children.

Johanna told her husband, Addis Osborne, about her project and he developed some marvelous little sketches that captured Uncle Mistletoe for the first time onto paper. Addis' background in art and drawing was just what was needed to depict this new whimsical character. Addis was an associate lecturer in charge of the children's classes for the Raymond Fund at the Chicago Art Institute.

When she brought her ideas and Addis' drawings of Uncle Mistletoe to the attention of John Moss and Lawrence Sizer, vice-president of finance, they immediately became enthusiastic. Mr. Sizer was at that time also director of public relations. Little did they know then how overwhelming the success of Uncle Mistletoe would become. During this meeting it was determined that something was needed to accompany the character, such as a story-poem in the windows.

ORIGINAL FIGURE OF UNCLE MISTLETOE FROM 1948. (Photo courtesy of Marshall Field's.)

114

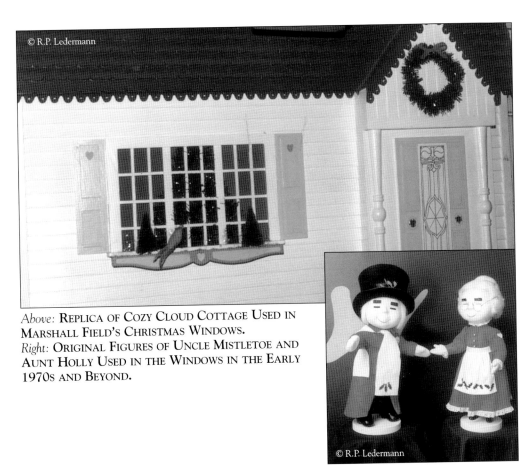

Above: REPLICA OF COZY CLOUD COTTAGE USED IN
MARSHALL FIELD'S CHRISTMAS WINDOWS.
Right: ORIGINAL FIGURES OF UNCLE MISTLETOE AND
AUNT HOLLY USED IN THE WINDOWS IN THE EARLY
1970S AND BEYOND.

Helen McKinna and Johanna created the first set of new windows for Field's with Uncle Mistletoe in 1946, "A Christmas Dream." It was their combined thoughts and love for this little character that made these and future Christmas windows such a success. Their simple idea of Christmas as being a time of giving and sharing with others was a strong theme in developing the character's personality. Special treatment and care was provided in every detail. The windows were such a triumph they were repeated again in 1947.

In these windows, Uncle Mistletoe is seen using a flying carpet. This concept as a method of transportation was taken from the classic story *The Arabian Nights Entertainments*, by Sir Richard Burton, one of Johanna's favorites.

The two youngsters, Jim-Jam and Joann, were patterned after her own niece and nephew. Naming Uncle Mistletoe, however, was a different story. Johanna wanted to use the name Marshall for Marshall Field, but after much discussion, it was decided to call him Uncle Mistletoe, "The Spirit of Christmas."

Just as Bob Cratchit needed Mrs. Cratchit and Mr. Fezziwig surely needed Mrs. Fezziwig, so did Uncle Mistletoe need a partner, a friend, a wife. Aunt Holly was all of these and more. She was affectionate, sweet, and she would take her place next to Uncle Mistletoe in the 1948 Christmas windows entitled "A Christmas Surprise." White haired Aunt Holly was always seen wearing a white apron over her red dress and matching red cape. She wears a cameo pin and her hair is pinned up in a bun. She wears reading spectacles to help her correctly read all those cookie recipes. It's not surprising that her favorite hobbies are baking cookies and sewing new clothes for Uncle Mistletoe. So together, starting in 1948, they were both recognized as permanent residents of "Cozy Cloud Cottage."

LIVE AUNT HOLLY AND UNCLE MISTLETOE CHARACTERS GREETED THE CHILDREN. Cozy Cloud Cottage was on Field's 8th floor. Each year, the wooden cottage would be all decked out and freshly painted. Youngsters waited up to two hours in long lines to finally have a visit with Santa Claus and to see a real live Uncle Mistletoe and Aunt Holly greet them, passing out "Official Kindness Club" buttons or perhaps a photo of themselves. Some years you even could have a 3-D picture taken with Uncle Mistletoe, in color, with a holder that folded into an envelope for mailing off to Grandma, all for $1.65. (Photo courtesy of Marshall Field's.)

DECEMBER 1949—YOUNG LOUIS K. HOUKAL JR., WITH FIELD'S SANTA. (Photo courtesy of Louis K. Houkal Jr.)

116

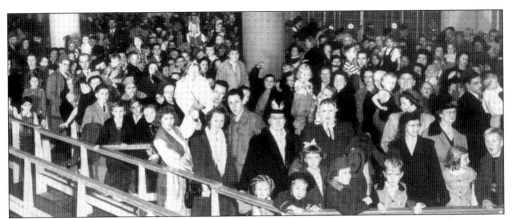

IN 1948 CROWDS OF CHILDREN WITH THEIR FAMILIES WAITED IN LINE TO VISIT WITH SANTA IN COZY CLOUD COTTAGE. (Photo courtesy of Marshall Field's.)

CHILDREN WEARING KINDNESS CLUB BUTTONS AND SINGING IN THE WALNUT ROOM IN 1949. Look at these children singing a song—perhaps they're singing the Kindness Club song. (Photo courtesy of Marshall Field's.)

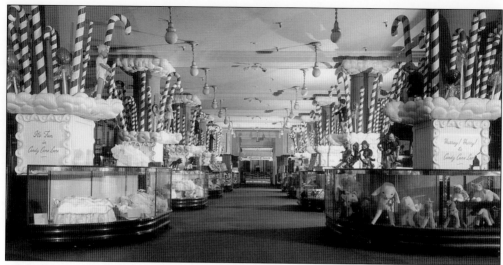

WIDE VIEW OF CANDY CANE LANE IN 1949. A day at Marshall Field's wouldn't be complete without a stop at the toy department, Candy Cane Lane, on the 4th floor. The toy department had giant candy canes hovering above you and below the counters were filled with fine quality toys from all over the world. Imaginative and fantastic toys; there were hand painted lead soldiers from England and hand carved wooden toys and dolls with real hair from Germany. There were stuffed animals, electric trains, and games. Of course, in 1948, you could purchase your very own original 15 1/2 inch high Uncle Mistletoe doll with removable hat and coat made of felt for $8.95, or a hand puppet for $2.95. A record sold for 79¢ and many other items dealing with Uncle Mistletoe could be purchased at the Gift Court Boutique located on the 2nd floor. (Photo courtesy of Marshall Field's.)

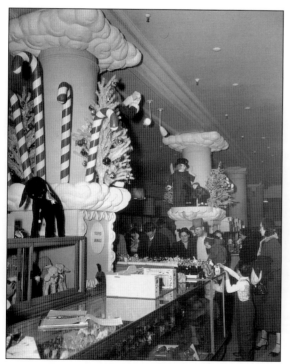

VIEW OF CANDY CANE LANE WITH UNCLE MISTLETOE ABOVE. The year 1947 brought the first full-scale production campaign for Uncle Mistletoe launched by Field's in newspaper ads, interior displays, direct mailings, and commercials on four local radio stations. Field's affectionately called Uncle Mistletoe "The Ambassador At Large for Santa Claus," and he would represent Jolly Saint Nick in all holiday festivities in the store as Master of Ceremonies while remaining "The Spirit of Christmas."

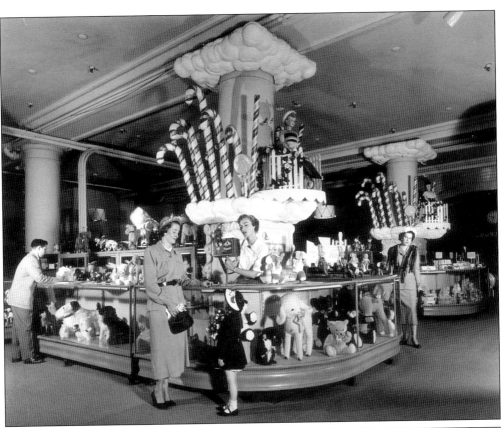

A MOTHER AND DAUGHTER SELECTING A TOY IN
CANDY CANE LANE. (Photo courtesy of Marshall Field's.)

UNCLE MISTLETOE HAND PUPPET USED ON THE TV
PROGRAM. Newspaper ads began with the traditional
Thanksgiving Day papers and ran through the Christmas
Day editions. The first series of printed ads would show
Field's colorful gift boxes, and the second series were
connected with the opening day of the traditional State
Street windows. The third series of ads were the gift
certificates, and the fourth showed a nostalgic scene called
Christmas Time. In the grand finale Uncle Mistletoe
appears in all the traditional holiday ads, saying to all his
newly met friends, "Merry Christmas to everybody." Famous
artists like Rainey Bennett or Francis Foley drew the ads.
In their drawings they had Uncle Mistletoe doing all the
favorite things we all do during the holiday season, while
pointing out that "Christmas isn't Christmas without a day
at Field's."

Uncle Mistletoe, to Marshall Field's amazement, took hold
of Chicagoland just as Rudolph the Red Nosed Reindeer had
with Montgomery Ward's and the Cinnamon Bear had for
Wieboldt's. (Photo courtesy of Marshall Field's.)

UNCLE MISTLETOE PUPPET FROM THE 1951 TV SHOW. As an assistant to Santa, never a rival, Uncle Mistletoe grew in popularity as more and more promotions developed his character and the basic theme of kindness. Due to the popularity of Uncle Mistletoe, in the fall of 1948 Field's developed a television show that debuted on November 15th. Children could now enjoy *The Adventures of Uncle Mistletoe*, which aired Monday through Friday from 5:45 to 6:00 P.M. on WENR, Channel 7 (now WLS). The show was produced by Steve Hatos and directed by Ed Skotch. Music was by Porter Heaps at first and later by Adele Scott. Sam Singer, a former Walt Disney illustrator, did all the animation and Ray Chan did the script writing. Sam Singer can be remembered for the creation of the popular Dopey character from *Snow White and the Seven Dwarfs*. Ray Chan, for old radio buffs, was the originator of *First Nighter* and *Grand Hotel*. (Photo courtesy of Marshall Field's.)

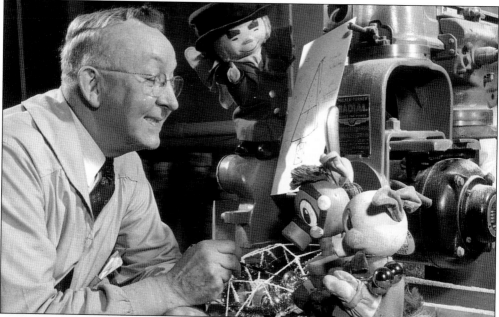

FROM LEFT TO RIGHT: ANTON FRITCH, DIRECTOR OF DISPLAY; UNCLE MISTLETOE; TONY PONY; AND OBEDIAH PIG. Uncle Mistletoe appeared as a hand puppet about one and one half feet high on the TV show where he shared the stage with Jennifer Holt, the actress, as Aunt Judy. Jennifer Holt, the daughter of the late Jack Holt and sister to Tim Holt (both cowboy actors), appeared in over fifty motion pictures. As Aunt Judy, she would lead the children into adventures in wonderland with Uncle Mistletoe. On each broadcast, the puppet Mistletoe would have cartoons by Sam Singer and Bill Newton. In some of the episodes we would meet new puppet friends like a hobbyhorse called Tony Pony and Skimp the monkey. There was Otto the elephant, Humphry the mouse, Michael O'Hare the rabbit, and Obediah Pig. Warren Best manipulated all the puppets. The voice of Uncle Mistletoe was that of the late Johnny Coons, a veteran Chicago radio and TV performer. He appeared at times on the radio show *Ma Perkins* and during 1942 was Rush on the *Vic and Sadie* show. He is also remembered for other television shows like *Noon Time Comics* and *King Calaco*, another puppet show for children. (Photo courtesy of Marshall Field's.)

FROM LEFT TO RIGHT: TONY PONY; UNCLE MISTLETOE; HUMPHRY MOUSE; ANTON FRITCH; DIRECTOR OF DISPLAY; AND MICHAEL O'HARE. (Photo courtesy of Marshall Field's.)

The Adventures of Uncle Mistletoe, in the first year of production, received a commendation from the City College of New York for its outstanding effects in television.

Originally, the show was to be seen only for the Christmas season. However, the show gained such an audience it was carried on into the spring. Uncle Mistletoe emphasized the need for kindness all year round.

Thus began the idea for the Kindness Club. Its membership required that each child write a letter to Uncle Mistletoe describing one good deed the child had done, and in return, each club member was rewarded with a copy of the "Kindness Club Song" and a Kindness Club button to wear with pride. These buttons were designed for the 1948 Christmas season. The button, designed by Addis Osborne, had a drawing picturing Uncle Mistletoe. These original buttons are now a prize to any collector of nostalgia. The club itself grew to a membership of 15,000 by June of 1949 when *The Adventures of Uncle Mistletoe* went on summer vacation.

These programs in the late 40s and early 50s were televised from the WENR penthouse studios located in the Civic Opera House. If you were to visit them you would find a large high-ceilinged studio filled with dozens of different props, cameras, and lighting grids. In the center of the stage stood the gleaming chrome microphone waiting for the show to start. The lights would come on and out stepped Uncle Mistletoe. Jennifer Holt's daily visits with the children ended in 1951 and Doris Larson, who was called The Look-Out Lady, succeeded her. At the beginning of each program she would pretend to be looking through a magic looking glass, and then she and Uncle Mistletoe would discuss past and future events.

In 1952 *The Adventures of Uncle Mistletoe* moved to WGN TV, Channel 9, and was viewed at 5:15 P.M. each Tuesday and Thursday. These shows were filmed by the Kling Studios and syndicated throughout the country. Fredrich and Nelson Department store, a division of Marshall Field's, sponsored the program in Seattle, Washington. The Chicago programs were sponsored by Field's alone.

The new programs introduced us to more puppet characters. We met Polly Dolly, Molio, Olio, Private Pepper, and the loveable as ever Aunt Holly. Different Mistletoe puppets were used throughout the shows. On each show a popular song would be played that tied in with the story of that day. Sadly, *The Adventures of Uncle Mistletoe* lasted only 13 weeks on WGN.

121

In 1949 the Kindness Club song was written and copyrighted by Marshall Field and Company, originally for the television program. Field's then recorded this song with the original voices of Johnny Coons as Uncle Mistletoe, and Jennifer Holt. This now rare recording sold at Field's for 79¢. It was entitled "Uncle Mistletoe in Wonderland" and featured three other characters on the program, Tony Pony, Obediah Pig, and Michael O'Hare.

In 1950, 10,800 children responded to a contest and received a copy of the words and music and a Kindness Club button. There was no special winner to the contest. Field's simply wanted to see the response to this new TV show's popularity.

The late Johnny Coons on the Decca label recorded still another song simply entitled "Uncle Mistletoe." The words and music were by Leonard Whitcup and Ray Madison. On the reverse side, Coons as Uncle Mistletoe relates "Uncle Mistletoe's Christmas." Eddy Howard and his orchestra on the Mercury label also recorded the "Uncle Mistletoe" song. "The Three Suns" were featured with vocal refrain by Texas Jim Robertson on another 45rpm recording of this song with an RCA Victor label.

THE KINDNESS CLUB SONG

"Uncle Mistletoe, says he, wants the boys and girls to be
In his Kindness Club to stay, if they're kind and good each day
Not just one day, not just two, but, be kind the whole year through
Oh…
Do a kind deed, say a kind thing, smile a big smile, everyone sing,
Feel the wind of kindness blowing,
Watch the way the vane is going,
Uncle Mistletoe is glad,
When you help your Mom and Dad,
Polish your button, give it a rub,
Everyone's proud of the Kindness Club."

© R.P. Ledermann

Above: SKETCH OF UNCLE MISTLETOE BY ADDIS OSBORNE. (Courtesy of Marshall Field's.)

Left: CLOSE-UP OF UNCLE MISTLETOE FIGURE ON TOP OF THE GREAT TREE FOR MANY YEARS.

UNCLE MISTLETOE. During Field's 100th anniversary, on a Monday morning just before all the Christmas decorations were to be unveiled, a charming surprise awaited all 15,000 Field employees. It was on that day the Uncle Mistletoe himself greeted them with a lapel pin depicting Uncle Mistletoe tipping his hat. The hat was white (not the usual black) and it had a large "C" on it. This was for the 1952 centennial year celebration! (Photo courtesy of Marshall Field's.)

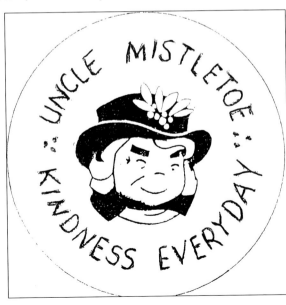

KINDNESS CLUB REGULAR BUTTON. (Photo courtesy of Marshall Field's.)

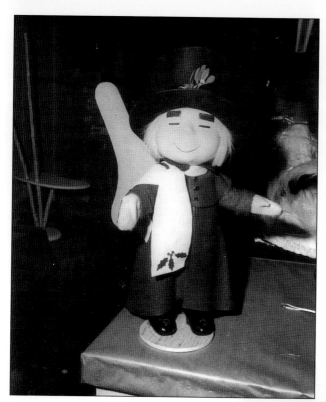

UNCLE MISTLETOE FIGURE
USED IN WINDOWS OF THE
1970S AND ON. They were
created and designed by Johanna
Osborne with poems by Helen
McKenna. Some of the story
windows where Uncle Mistletoe
appeared were: 1946, "A
Christmas Dream"; 1947, "A
Christmas Dream" (repeated);
1948, "A Christmas Surprise";
1949, "The Christmas List";
1950, "A Party for Santa"; 1951,
"The Night before Christmas";
1952, "The Christmas Alphabet"
(Santa's Christmas Letters);
1953, "Santa's Christmas
Recipes"; 1954, "Santa Christmas
Cruise"; 1955, "The Christmas
Calendar"; and 1956, "A Gallery
of Greetings". (Photo courtesy of
Marshall Field's.)

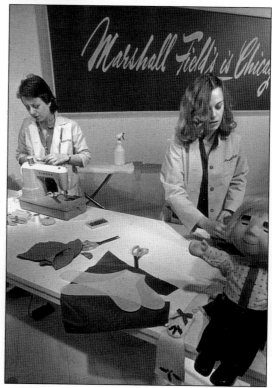

UNIDENTIFIED EMPLOYEES MAKING
CLOTHES. Each year Uncle Mistletoe
was fitted for the windows in a new set
of hand-made clothes. (Photo courtesy of
Marshall Field's.)

During my research in the 1980s, I came across the poem printed below. It has never been published before, and the author is unknown. It is simply entitled: "The Story of Uncle Mistletoe."

THE STORY OF UNCLE MISTLETOE

(author unknown)

In a mystical, magical land far away,
Where the moon lives by night and sun lives by day,
Deep in the heart of the land called "Kerchoo,"
Not very far from the river Aldoo,
There lives in a house a most wonderful man,
I remember they call him "the king of the land,"
You may have heard of him—maybe perchance?
I know just a word from him makes your heart dance!
You know him by name—Uncle Mistletoe's he,
A name that is known from the sea to the sea.

"But how did he come by that name?" you may ask,
"What did he do? What marvelous task?"
I tumbled these questions around in my mind,
I tumbled them forward and back and behind,
At last I decided to go out and see,
To see what the answer he'd give me would be.
I know where to look for him—surely no doubt!
There's one man that Misty is never without,
And that's with good reason, I found out, because
This one special man has the name Santa Claus.

I took to the air on the wings of a dream,
And landed by Santa there training his team,
I asked him about Uncle Mistletoe's name,
I asked him from where Uncle Mistletoe came,
He then sat me down on his knee and he smiled,
And asked, "Why are you such a curious child?"
I told him that I really wanted to know,
I told him, "I love Uncle Mistletoe so!"
He said, "Right up there is the river Aldoo,
And there Uncle Mistletoe's waiting for you."

And gosh! He was right! For I looked up ahead,
And there was the little man all dressed in red!
I knew by those sparkling eyes who he was,
(I cannot describe what a glimpse of them does!)
He said, "Ah! You're Billy that marvelous man,
Who asks all the questions I don't understand!"
"How do you know who I am?" I did cry,
"How do I know? Well, because I am I!"
Then Santa stood up and he started to leave,
And he said, "Tell this boy of your first Christmas Eve!"

Uncle Mistletoe laughed with that laugh all his own,
And he said, "Long ago Santa Claus worked alone."
"No," I said, mystified, "that cannot be!
Santa has elves – Seven hundred and three!"
He said, "Why do you never ask of the elves?
Where do you think that they come from themselves?"
"I do not know," I then said with a sigh,
"I don't understand and I can't even try!"
Uncle Mistletoe chuckled, "Well, come sit you down,
I'll tell you of when there was no Christmas Town. . . ."

"Santa had lived long ago by himself,
His only elf then was a toy on a shelf!
But people were growing in numbers each day,
The presents could not even fit on his sleigh.
Year after year he came through right on time,
Year after year every chimney he'd climb,
But with every step that old Santa would take,
His laughter would weaken—his sad heart would ache.
He knew that the next year there'd be even more,
And that was the Christmas of 1904!

"Gee!" I exclaimed, "How did Santa survive?
How can that poor, tired man be alive?"
"Listen, you'll know," Uncle Mistletoe said,
Beaming in warmth from his toes to his head.
At the end of the Christmas of 1904,
Santa decided that he'd do no more;
"With no one to help me it's all I can do
To wrap up the gifts and deliver them, too!
I'm hoping and praying that someone will hear,
And help me with Christmas time year after year!"

"And then in a flash I appeared to him there,
I told him I'd come in response to his prayer.
What I said to Santa to you I'll impart;
'I'm the spirit of Christmas that lives in your heart—
The spirit of living in kindness and love,
The spirit of giving that all men dream of—
Your Uncle in spirit and living in you,
And like mistletoe fresh and green when it's new
I symbolize all that your Christmas should be;
I'm the hope and the love that you always can see.'"

"And then in a flash I delivered the elves!
They filled up his pantries and closets and shelves!
The toys were so many we couldn't keep track!
(Elves, you see, always have had quite a knack
For helping out people who desperately need
Assistance in doing some good, kindly deed.)
They come from the world of Imagination,

Where Christmas is always a real celebration,
They live now with Santa—they built Christmas Town
With their kindness and love that they spread all around."

I must have been crying; he noticed a tear,
And he said, "Are you crying from laughter or fear?"
"Neither," said I, "I was crying because
There's so much to Christmas I never thought was!"
He said, "You thought that Christmas was only a season?
Then your celebration was for the wrong reason!"
"I see now!" I said, "Oh, I see it so clearly!
Christmas means giving to those you love dearly!"
"No," he said, "Christmas is never that small!
Christmas means giving—and giving to all!"

Giving to all? But what could I give?
What could I give to each person that lives?
I was going to ask him about what he said,
And the next thing I knew I was home in my bed!
Now I was right back where I had begun,
I'd looked for the answer, and I had found none.
But just then I saw something up by my books,
And I leapt from my bed so I might take a look.
There on the shelf was a little toy elf—
Holding a sign that said, "GIVE OF YOURSELF."

(With permission and courtesy of Marshall Field's Archives.)

As Mistletoe's popularity grew, so did the wide variety of merchandise. There were ceramic cookie jars and glass tumblers. Children would choose from rubber squeeze toys, dolls, puppets, banks, and even a "Little Golden Book." A real prize for today's collector are miniature hand-painted lead figurines made in England. There were paper products, napkins, get-well or Christmas cards, candles, and coloring books. They also had linen hand towels, cloth napkins, and aprons, in addition to place mats, Christmas tree skirts, felt pendants, wine decanters, jam crocks, and decorative brooms. For the true collector, a limited edition "Sebastion" miniature is a true find. Popular also were glass canisters, toss pillows, and needlepoint stocking kits. They made T-shirts and door knob covers, and the list goes on and on. Sugar cookies were baked in Field's own bakery shop.

The most collectible items antique hunters of today love to find are the early glass tree ornaments. These first sets of ornaments were hand-painted blown glass and were made in Germany exclusively for Field's. A few years later new glass molds would be made in Austria. Throughout the years various sizes and newly shaped ornaments appeared from manufacturing companies around the world. The last Mistletoe ornament was made by Radko. In recent years Field's introduced a new Christmas character, Mistletoe Bear, who was later Santa Bear. There was also a Mrs. Santa Bear.

And who could forget in 1973, Freddy Field Mouse, his wife Marsha in 1977, and in 1980, their family of four: Franklin, Forrester, Flora, and Fanny? Just as Marshall Field's continues to develop new projects and ideas, so does Chicago and its State Street. Fields remains the crown jewel of State Street to this day and State Street is, and always will be, a Great Street!

I can find no better way, in closing this chapter than in this simple poem by my wife, Annette, entitled, "Kindness."

KINDNESS

It's never too late to start being kind,
For the mysteries of Wonderland stay in my mind.
The wonder of Mistletoe will stay in my heart,
He'll always be in my Christmases from the very start.
His job you see, is somewhat of a task—
He has to make sure our memories will always last!
He has a job up in Wonderland today,
He flies about and checks children at play.
See you soon, you happy little man,
Keep on doing exactly the best that you can—
Remember, take the time to be kind and keep happy in your thoughts,
Because Christmas is forever, and these days are not.

by Annette M. Ledermann

AUTHOR ON REINDEER WITH SANTA.

© R.P. Ledermann

CLOSING REMARKS

Christmas is still a time of wonder for the child in all of us. In this day and time, filled with life's uncertainties, let's hope and wish that each of us, young and old alike, can keep that wonder alive in our hearts, and may we always act with kindness and stay happy within ourselves. I believe the next generation will keep this dream alive. Thank you for letting me share with you the wonderful excitement and magical memories of State Street at Christmas time.